The Moderate

Frost's space is deeper than Poliakoff's and not as deep as that of Soulages.
 Patrick Heron, in *Arts*

'Soulages's space is deep and wide –
Beware!' they said. 'Beware,' they cried,
'The yawning gap, the black abyss
That closes with a dreadful hiss!

'That shallow space by Poliakoff,'
They added, 'is a wretched trough.
It wrinkles, splinters, shreds, and fades;
It wouldn't hold the Jack of Spades.'

'But where?' I asked, bewildered, lost.
'Go seek,' they said, 'the space of Frost;
It's not too bonny, not too braw –
The nicest space you ever saw.'

I harked, and heard, and here I live,
Delighted to be relative.
 John Updike

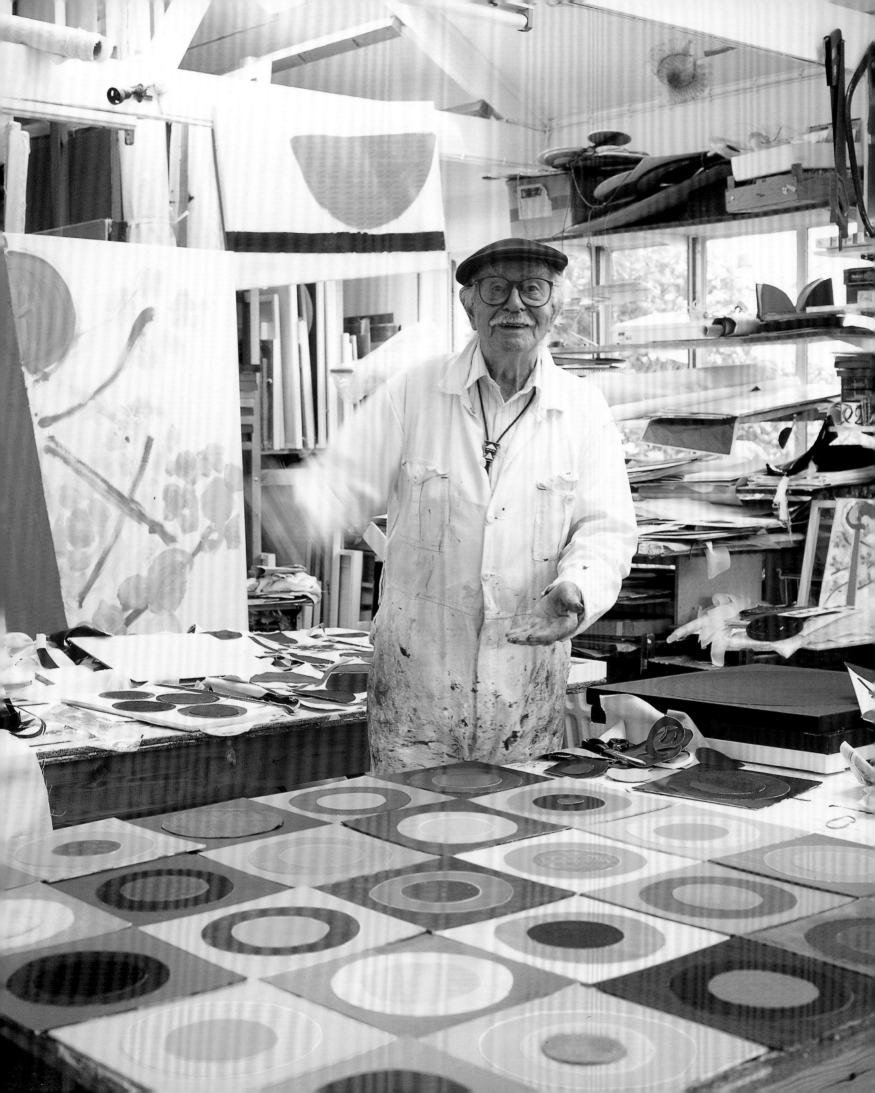

Terry Frost
Six Decades

Royal Academy of Arts

First published on the occasion of the exhibition
'Terry Frost: Six Decades'

Royal Academy of Arts, London
12 October – 12 November 2000
Supported by Paul and Alison Myners

This catalogue has been generously supported
by Martin Krajewski

Mead Gallery, Warwick Arts Centre,
University of Warwick
10 January – 16 March 2001

The Royal Academy of Arts is grateful to Her Majesty's
Government for its help in agreeing to indemnify the
exhibition under the National Heritage Act 1980, and
to the Museums and Galleries Commission for their
help in arranging this indemnity.

Exhibitions Secretary
Norman Rosenthal

Exhibition Curator
Isabel Carlisle

Exhibition Organiser
Harriet James

Photographic and Copyright Co-ordination
Miranda Bennion
Andreja Brulc
Roberta Stansfield

Catalogue
Royal Academy Publications
David Breuer
Sophie Lawrence
Soraya Rodriguez
Peter Sawbridge
Nick Tite

Design
Kate Stephens

Picture research
Julia Harris-Voss

Colour origination
The Repro House, in association with
Robert Marcuson

Printed in England

British Library Cataloguing-in-Publication Data
A catalogue record for this book is available from
the British Library

Distributed in the United States and Canada
by Harry N. Abrams, Inc., New York
ISBN 0-8109-6635-2

Distributed outside the United States and Canada
by Thames & Hudson Ltd, London
ISBN 0-900-94687-3

Limited edition
ISBN 0-900-94691-1

Photograph of Terry Frost in his studio (p. 2) and
detail of the studio (p. 87) by Richard Waite

Details:
pp. 4–5, cat. 22
pp. 10–11, cat. 33
pp. 26–27, cat. 12
pp. 48–49, cat. 19
pp. 66–67, cat. 36

'The Moderate' is from John Updike, *Collected Poems
1953–1993* © 1993 John Updike. Reprinted by
permission of Alfred A. Knopf, a division of Random
House Inc.

'Madrigal', from 'Twelve Songs II', is from W. H.
Auden, *Collected Shorter Poems 1927–1957*, Faber
& Faber Ltd.

'Song of the Rider' is from *Selected Poems of Federico
Garcia Lorca*, translated by Lysander Kemp © 1955 by
New Directions Publishing Corp. Reprinted by
permission of New Directions Publishing Corp.

Lenders to the Exhibition

Innocent Fine Art Ltd, Bristol

Bristol Museums & Art Gallery

The British Council

McGeary Gallery, Brussels

Mr and Mrs W. F. Couch

Scottish National Gallery of Modern Art, Edinburgh

Sir Terry Frost

T. L. Johnson

Ferens Art Gallery: Kingston-upon-Hull Museums
 and Art Galleries

Leamington Spa Art Gallery and Museum,
 The Royal Pump Rooms (Warwick District Council)

Tate, London

Private collection, courtesy Belgrave Gallery

Frances and John Sorrell

John and Marilyn Wilkie

and those lenders who wish to remain anonymous

Contents

Supporters' Preface

We have admired and collected the art of Terry Frost for the last dozen years. More recently we have formed a friendship with Terry and Kath, which has brought an added dimension to our appreciation of Terry's work.

Terry's use of pure and vibrant colour, light and texture produces imagery directly related to natural phenomena. It is a joy to experience. Each of his works reflects his infectious enthusiasm for life.

We are delighted to support this exhibition, which celebrates, on the occasion of his eighty-fifth birthday, Terry's remarkable artistic achievement over six decades.

Paul and Alison Myners

President's Foreword

Sir Terry Frost is one of the Royal Academy's most celebrated Senior Academicians. The retrospective with which we are now honouring him spans the work of six decades, from the 1940s to the present day. It is a remarkable achievement to have sustained a consistently vital reappraisal of the possibilities of abstraction over such a span of time. Frost's particular abstraction is sensitive to the limitations of rendering the world in two dimensions. At the same time it transcends that world through the sensations that can be experienced in nature. The triumph of Frost's art is that, through colour and shape, it transmits an extraordinary joy that no viewer can fail to respond to.

We would like to thank all supporters of Sir Terry's work who have encouraged this exhibition, and in particular the lenders. Our thanks go also to Mel Gooding, who has contributed a perceptive assessment of the artist's work for the catalogue, and to Sir Alan Bowness and Chris Stephens, who both generously gave their time to advise on the content of the exhibition. At the Academy Isabel Carlisle, Exhibition Curator, has selected the exhibition and been involved in all aspects of its organisation, together with Harriet James, Exhibition Organiser.

Without the financial generosity of Paul and Alison Myners, who have been long-term supporters of the Academy, this exhibition would not have been possible. To them we extend our sincere thanks. Martin Krajewski has once again most generously sponsored the catalogue of an Academician's exhibition, for which we are most grateful.

Professor Phillip King CBE
President, Royal Academy of Arts

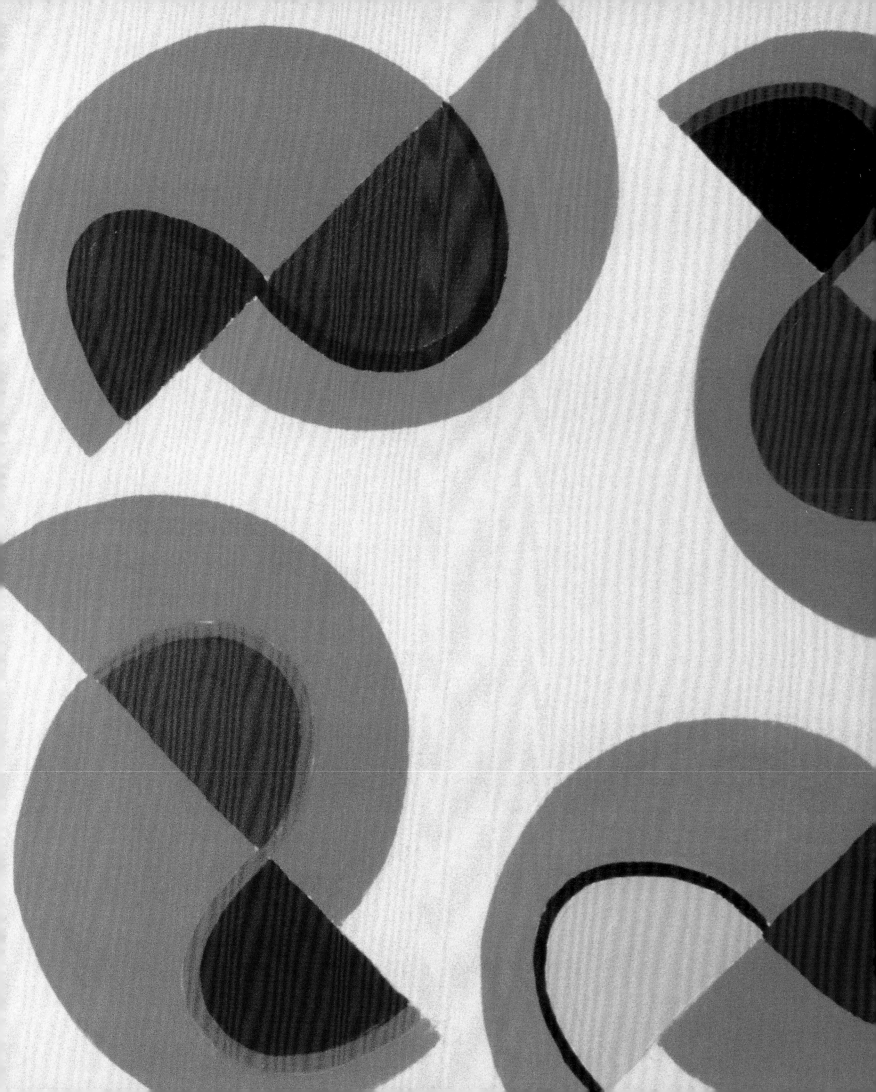

Mel Gooding

The Intelligent Eye

On the art of Terry Frost: critical contexts and creative purposes

Finding a Language

Some time in early 1948 Terry Frost, at the time a mature student at Camberwell School of Art, stood in front of Rubens's *Judgement of Paris* in the National Gallery (fig. 1). It was a defining moment in his life as an artist. Frost was not familiar with the myth to which the painting referred, and in any case it was not the story it told that interested him. He was there to learn about painting as such, and Rubens's treatment of the classical theme, with its three goddesses in competition, had much to teach him:

> I looked at the painting and the painting had to stand and fall by the painting. Now this is nothing to do with the story; the thing that fascinated me about the painting was that you've got the same figure used three times, side back and front, so it makes a D-shaped turn. Three reds, one in the tree, one on the central model, one on Paris; eye-glance to make space: there is so much going on in that painting. The same things go on in 'modern art'.[1]

What Frost was learning by direct visual experience of a great narrative painting at the centre of the post-Renaissance figurative tradition was something about the *abstract* dynamics of picture making, about how an implied structure of relations in three-dimensional space informs the pictorial drama and gives it life. There can be no doubt, either, that he would have appreciated the quick sensuousness of the three female figures, and recognised that in the disorder of their capes, their state of *un*dress, Rubens had rendered his nudes naked. This too was bound to make a strong impression upon a passionately instinctive artist, subject at the time to an academic training dominated by life-room studies in which the still pose and position of the model was precisely fixed and maintained. Students were expected to develop an exactitude of attention to what was considered a task of purely observational probity: what was perceived in real space bore a directly objective relation to what was realised on the paper or canvas.

Teaching at Camberwell in the late 1940s was dominated by those artists who before World War II had formed the Euston Road School. William Coldstream was the acknowledged leader of this group, which included William Townsend, Claude Rogers, Lawrence Gowing, and the rather more unorthodox Victor Pasmore. Frost's close friend and artistic mentor, Adrian Heath, has described with a wry precision the procedures of figure drawing and painting that were *de rigueur* under this regime:

> The discipline in the life room was based on measurement used as a principle of construction rather than as a corrective to a faulty eye. One could spot the work of a serious student (and Frost enjoyed the company of many serious students between 1947 and 1950) by the way a crop of marks would appear, like a rash, on the canvas. These marks were reference points on the model that would correlate with other points of reference in the background and it was some time before the artist could risk stating

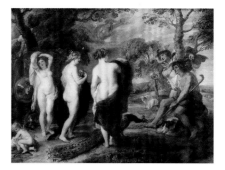

a contour line. For the success of the operation it was essential that the model should hold the pose unflinchingly from session to session and that the student should mark the position of his own easel and footmarks on the floor before starting to measure with stick and plumb-line. It was thought that this system might promote a search for truth along objective lines and that it would discourage vulgar virtuosity that comes from a mastery of traditional conventions, as well as those brash simplifications that laid claim to expressionism.[2]

Heath, who as a fellow prisoner of war first encouraged Frost to consider an artistic career, had urged him to take a place at Camberwell, thinking that his native predisposition to a 'Romantic' spontaneity would benefit from 'a little external discipline, a touch of classical control'.[3] In addition to the constant life classes there were studies in perspectival geometry and the rules of the Golden Section, and formal geometric analysis of paintings by artists ranging from Piero della Francesca to Seurat. In the painting studios Frost, recognising other kinds of truth in painting than the limited, and limiting, idea of objective factuality, found the dominant Euston Road realism unsympathetic. He was nevertheless conscientious in his studies at Camberwell, as might be expected of one already in his thirties, who had come late to his vocation, and, married and living on a postwar ex-serviceman's grant, was already committed to the precarious exigencies of a life in art. As with all genuinely original artists, his true study was the art of those others, from the Old Masters to his closest contemporaries, whose discoveries and inventions provoked him to discover and invent things for himself.

Victor Pasmore, though closely associated with those described by Frost as 'the Coldstream Guards', and held, somewhat ruefully, in high esteem by them (he had recently been published in the prestigious Penguin Modern Painters series, with an essay by Clive Bell, the doyen of English art criticism) was a law unto himself; much to their dismay, Pasmore was, in early 1948, moving towards abstraction. 'I don't believe in this looking at nature', he said, with typically emphatic exaggeration, to William Townsend in March 1948. 'Looking at nature never made anyone want to paint pictures. You only want to do it and learn how to by looking at other pictures.' Townsend, recording this in his journal, also remarked that 'V. has little use for drawing in the life room and it is very rarely indeed that he gives an individual lesson there.'[4] One lesson he gave at that time, however, was to have momentous consequences. Frost, who deeply admired Pasmore, was the recipient: 'I'd been in the class, doing what was expected, for about an hour and Pasmore said "I see you've finished." I said "this is what I really do" and turned the board over to show him my own work. He told me not to come in any more – "go round the National Gallery, go round the modern galleries!"' As for registering the attendance at Camberwell necessary to maintain a grant: '"get someone else to sign you in" he said.'[5] Frost assiduously followed Pasmore's peremptory advice to 'look at other pictures', though, characteristically, he also continued until 1950 to attend punctiliously at the school.

Frost has often spoken of the importance to his development of the close attention he paid to the art he found in the National Gallery during those years. Rubens's *Judgement*, which he has always associated with the Antique motif of the Three Graces, has continued to fascinate him:

> *If you draw the direction of the glances, the glance of the girl in three positions, and the glance of Paris over on one side, you have a wonderful series of geometric forms informing the structure of the painting. You have the figures doing a semicircle, lights and darks and three flashes of reds, giving a series of time–space–colour movements forming a structural continuity.*[6]

This vivid apprehension of a three-dimensional geometry of relations enacted in imaginative time and space, realised in visual rhythms and repetitions of form and colour, was an experience quite different from that provided by the academic analysis of perspective and the Golden Section in sepia reproductions at Camberwell. It provided crucial lessons about the ways in which the formal organisation of a painting could create effects upon the spectator that had nothing to do with its ostensible subject matter. A 'structural continuity' of 'time–space–colour movements' abstracted from any direct or naturalistic description of the world would be precisely what Frost would set out to create in his mature painting. 'The geometry is the discipline that gives you the assurance, the confidence, to take risks and make the moves. The Rubens teaches you that.'[7]

Frost thus learnt in his own way from Rubens and other artists in the National Gallery, studying the architectonics of Piero's *Baptism* and the complex play between interior and exterior spaces in Antonello da Messina's marvellous *St Jerome in His Study*. He studied them as a painter working towards his own, highly individualised, version of modernist abstraction, distinguished by its emphasis on form, space and colour as elements invoking imaginative response by their active relations within the pictorial frame of the canvas itself. He was, in this respect, one of that remarkable generation of painters described by Patrick Heron as having 'come to grips with painting – painting as distinct from a poetic, illustrator's art, an art dominated by symbol and literature'.[8] Heron's 'middle generation' of Frost's contemporaries was in fact a very diverse bunch (it included Pasmore, Heath, William Scott, William Gear, Roger Hilton, Bryan Wynter and Peter Lanyon among others); what they had in common was a heightened awareness of synthetic or decorative Cubism, of Matisse and French post-Cubist painting, and of Mondrian. Not surprisingly, Ben Nicholson was for many of them the pre-eminent English artist of the previous generation, and an acknowledged influence, though not necessarily in terms of style. These artists had no interest in postwar neo-romantic variations on English visionary themes, or in the earnestly tonal realisms of the Euston Road or 'Kitchen Sink' varieties. They were interested rather in making paintings that had their own pictorial logic, intuitively arrived at, and which referred at most only schematically or tenuously to objects in an actual space external to the picture itself.

Pasmore was important to Frost as more than the provider of a potent piece of advice.

fig. 2 Victor Pasmore, *Square Motif, Blue and Gold: The Eclipse*, 1950. Oil on canvas, 46 × 61 cm. Tate, London 2000

The pinks, browns and blues of Frost's *Self-portrait* (1948–49, cat. 6) are close to those of Pasmore's palette at the time, and the simplification of the vase and flower forms is very much like Pasmore's treatment of similar subjects; more significant, however, of his development of a truly personal manner is what Heron described as 'a dry opulence of touch' – an 'extremely subtle feeling for surface' which Heron suggests, with the visual acumen of a fellow painter, that Frost had 'absorbed' from Pasmore. Frost visited Pasmore at his studio in Blackheath in 1948–49, a period during which the older artist was experimenting with the quasi-geometric paintings and collages that led to his first completely abstract reliefs. Pasmore's exhibition at the Redfern Gallery in November– December 1948 included the last of his figurative and the first of his new abstract works. His rapid 'conversion' (as it was called) to abstraction over the following year caused critical consternation; Ronald Alley has described it as 'one of the most dramatic events in post-war art'.[9] Given the atmosphere at Camberwell and the general scepticism at the idea of abstract art in the late 1940s it was remarkably single-minded and brave of Frost, so close to the beginnings of his professional career, to opt for abstraction, and there can be no doubt that Pasmore's principled example was crucial. Seeing Pasmore's early constructions in the studio was a liberating experience: 'Painting a portrait or a flower piece – though there's nothing wrong with that at all – seemed then to be a limitation on conception and optimism. Everything suddenly began to open up.'[10]

Among other teachers important to him in the years at Camberwell was Kenneth Martin, an artist of generous intellect and great integrity, and throughout this time Frost also maintained close contact with Adrian Heath, at whose house in Fitzroy Street he met Anthony Hill and Martin's wife Mary. In 1951 the mercurial and intelligent Roger Hilton became a close friend and companion in art: in the early 1950s they travelled to Paris, studying pictures in the Louvre together and visiting the Left Bank galleries; from that time on they were constantly in conversation and correspondence about the nature of painting, in particular the relation of abstraction to figuration, and the problem of meaning in abstract art. All this placed Frost in his formative years near to the centre of an intensely serious postwar British avant-garde whose primary creative preoccupation was with the possibilities and meanings of abstract art. '[I]t takes several people working intuitively along certain lines, roughly related, to make something new,' wrote Hilton in a letter to Frost in the early 1950s. 'Altogether I had one of the best trainings anyone could get,' Frost reflected later, 'because I met people who each in their own way were genuinely trying to do something.'[11] What was especially important was that these friends were artist-intellectuals, knowledgeable of history and unafraid of theorising. In this formidable company Frost obstinately forged his own identity, absorbing what he needed, defining his purposes with an admirable independence of spirit. English artists' groups, it might be remarked, rarely maintain formal or ideological cohesion; friendship and personal respect, and academic or geographic proximity usually count for more than adherence to a theoretical 'line'. Frost was able to take his own path while maintaining valuable friendships with artists whose temperament and purposes were very different from his own.

In 1951 Kenneth Martin wrote an editorial for a pamphlet 'devoted to abstract art' that exemplifies a prevailing tendency of thought. It demonstrates the difficulties of definition that varieties of non-representational art created for the practitioner-theorists of 'abstraction':

> What is generally termed 'abstract' is not to be confused with the abstraction from nature which is concerned with the visual aspect of nature and its reduction to a pictorial form; for, although abstract art has developed through this, it has become a construction or concretion coming from within. The abstract painting is the result of a creative process exactly the opposite to abstraction. ... Just as an idea can be given form so can form be given meaning. By taking the severest form and developing it according to a strict rule, the painter can fill it with significance within the limitations imposed. Such limitations have been constantly used in poetry and music. ... The square, the circle, the triangle etc., are primary elements in the vocabulary of forms, not ends in themselves. ... Proportion and analogy are the base of such a pictorial architecture. The painting grows according to these laws and these have their counterpart in the laws of nature. Not painting which imitates the illusory and transient aspects of nature, but which copies nature in the laws of its activities. ... [The painter] attempts to create a universal language as against a private language. ... Heroic efforts have been made towards the creation of this language.[12]

Pasmore described his own progress as 'changing the process of painting from one of visual abstraction to that of intrinsic and organic construction'.[13]

Madrigal (1949, cat. 7) was Frost's first successful abstract painting. The subject was set as a Camberwell summer assignment, and Frost was inspired by W. H. Auden's song-like poem of that title, of a collier's love for his girl, to create a music of sonorous colour-shapes (see p. 30). Frost's *Madrigal* is an assured performance in which the interlock of rectangles, triangles and diamonds, and the interplay of opaque and translucent elements, may owe something to Pasmore's first small abstracts of 1948 but, more remarkably, it *anticipates* the horizontal deployment of geometric shapes in Pasmore's *Square Motif, Blue and Gold: The Eclipse* (fig. 2) and similar paintings of the following year. Frost was by this time entering into a creative dialogue on an equal footing with his more experienced abstractionist friends; aware of the formal principles of 'a pictorial architecture', he nevertheless acknowledged the subjective sources of his own art: 'I subdivided the flat surface with the Golden Section and the square so that every geometric shape was related to every other shape, *and then I used colours emotionally*.'[14] Music, poetry and love were essential elements in the composing of *Madrigal*.

Frost had in fact been struggling for months to determine a direction for his painting: *Madrigal* resolved the problem, but not in quite the way that he would find satisfactory for very long. The response of Leonard Daniels, the Principal at Camberwell, was at once uncomprehending and condescending: 'This kind of thing is all right,' he remarked, 'as long as it's not an end in itself.'[15] This made little impact upon the artist, for Frost was already intensely committed to painting as an end

in itself, in the sense that its forms and colours, and their relations to each other, were determined by the constructive principles of the particular work, rather than by any attempt at the imitative description of things as perceived in the phenomenal world. Frost had moved beyond the discipline of objective observation and the tendentious rigour of 'realism', to the deeper discipline of the visual imagination, in which the creative play of formal relations was constrained by those 'limitations of form [that] have been constantly used in poetry and music'.[16] Regardless of what this might mean to other abstract artists, for Frost this in no way implied a metaphysical or quasi-spiritual function for painting. He has steadfastly refused to resort to the high-flown rhetoric that has so often accompanied abstraction; keeping his feet on the ground and his eyes on the actual, he has developed and exploited a wonderfully subtle, and supple, visual language of sign and analogy. It is the uses of that language to which I now turn attention.

The Uses of Abstraction

Walk Along the Quay (1950, cat. 8) was among the first paintings Frost made once settled back at St Ives, where he had made his home in 1946. It announced both a theme and a manner that became his own. Abstraction for Frost was to be essentially an assertion of the autonomy of the image, of its self-sufficiency; but this was not to be purely formal, a matter of arranging geometric components into constructions that belie any relation to experience, visual and otherwise, of the world beyond the canvas edge. In this respect Frost parted company at the outset, and in a fundamental way, with his more rigorously theoretical comrades, for he has always admitted into the process of composing a painting aspects of a direct response to the external world, however transformed into purely formal relations of line, plane and colour. In the figurative paintings he made in 1947 and 1948, before his breakthrough to abstraction, it is already possible to see a simplification of certain objects into characteristic linearities and colour-shapes whose rhythmic interrelations create purely pictorial effects independent of mimetic description: the yellow striped dress and the blue pram in *Battersea Park* (cat. 4); the succession across the canvas of quasi-geometric vertical shapes in the conversation piece set in Back Road West, St Ives (cat. 3); the reverse-echo of curve and arabesque in *Miss Humphries* (cat. 5; Frost has described this latter as 'one of the most important paintings of my life'[17]).

In *Walk Along the Quay* he created an image that does not attempt the description of a given scene according to any of the available pictorial devices, including the flattened and formalised representation of Matisse, of whose work Frost was keenly aware, and yet it undoubtedly contains information about tangible aspects of time and place. It develops the emotive colour-geometry of *Madrigal*, but the references in that earlier painting to its poetic source are pure signs: its effects are achieved by abstract contrasts of light and dark, colour and tone, and by the simple programmatic disruption of horizontal poise by the 45° rotation of rectangles in the upper half of the canvas. *Walk Along the Quay*, by contrast, refers to the light, colour, objects and movements

of a specific place: its horizontals recall the sea's horizon, its curves are signs for the hulls of boats, its half-discs signs for sun and moon. It seeks, moreover, to do more than simply reduce to abstract signs the objective components of the scene, to paint the light and the things it makes visible. As its title implies, it sets out also to convey the sensation of movement through space and time.

The problem Frost faced was that of the consciously modernist painter: how to create a complex experience for the spectator without recourse to those representational devices that had dominated Renaissance and post-Renaissance art – perspective, imitative colour and tone, figurative modelling, etc. – whose purpose was to direct attention to the objects and events portrayed, to picture objects or tell a story. 'The thing of interest is the actual life of the work,' Adrian Heath wrote a few years later of his own painting, 'its growth from a particular white canvas'.[18] Frost would have found Heath's emphasis on 'direct and continuous contact' with the objective materials and media – 'their existence as form and colour … the size and format of the area to be painted' – highly sympathetic, as accurately defining the conditions with which a work begins. The success of *Walk Along the Quay* is indeed determined by the shape and size of the canvas, which Frost 'happened to have'. But in his own work he stopped short of what were for Heath the further implications: that the picture could be developed by a 'logical' process to a set of formal relationships controlled by mathematical disciplines of number or measurement. (Like Pasmore, Heath was in fact more intuitive and 'subjective' in his practice at the time than his more emphatic statements might suggest.) Anthony Hill, characteristically, was more rigorous:

> Abstract art [was] a non-mimetic art aiming at an esthetic of objective invention and sensation, distinctly rational and determinist. … The work is the sum of what is in it and can be considered as the resolving of the situation where all variants of a formalised thematic grouped by criteria are ordered by principles of hierarchy.[19]

Frost would not (temperamentally *could not*) thus exclude sensational or emotional experience from his painting. Indeed abstraction was for him precisely the means to a more vivid and truthful expression *in concretely objective terms* of that immaterial complex of sense perception and response, seeing and feeling, of 'giving, receiving and giving again', that constitutes a moment of being in the world.[20] This was anything but 'distinctly rational and determinist'. It was to be achieved, necessarily, through a physical engagement with materials, a direct involvement in 'their existence as form and colour', grounded in the recognition of their intrinsic and specific qualities. Frost was committed to that higher kind of 'realism' which Léger had defined as early as 1913, at the moment when he briefly saw abstraction – 'pure painting' – as the logical conclusion of Cubism: 'the *realistic* value of a work is completely independent of any imitative character … pictorial realism is the simultaneous ordering of three great plastic components: Lines, Forms and Colours.'[21] Each art would maximise its own intensity of expression by 'isolating itself and limiting

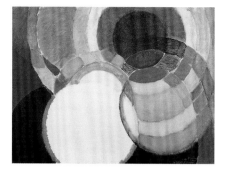

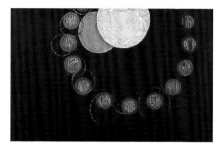

itself to its own domain'. Reference to Léger is pertinent here, because it suggests that the provenance of Frost's particular kind of abstraction is in Cubism rather than in the Constructivism that so greatly influenced the theory and practice of his friends the Martins, Heath, Hill and Pasmore. Cubist-derived painting always keeps one eye on the world and its objects and one on the canvas, seeking to transform perception (which is necessarily subjective) into dynamic image; Constructivism, on the other hand, creates objects (including paintings) whose internal relations (of material, form and colour) are intrinsic and self-referential. 'The work of the constructive or concrete artist', wrote Kenneth Martin, 'is not an interpretation of forms he has seen and been carried away by, but an object itself.'[22]

Frost has been happily inclined to turn aspects of Constructivist imagery to his own purposes, but the underlying impulse of his work has been towards the discovery of a precisely abstract image-equivalence for actual experience. The making of *Walk Along the Quay* was for him a revelation of this possibility.

> *Abstraction had taught me to recognise the flat surface. … How was I to paint the experience I was having in this locked harbour?… I really did think there was a chance of making something happen* **in an analogous way on the flat surface, flat surface being the vital important start***. From understanding that, you can move into colour and what it does by intensity, proportion, overlap etc. … Colour for feeling, to do with imagination and reverie,* **inspired by actual experience***. … Walk Along the Quay came from a true walk … the constant movement always intrigued me. … Things were happening to my right and beneath – my feet felt and saw all the shapes of boats . …. The strange feeling of looking on top of boats at high tide and at the same boats tied up and resting on their support posts when the tide is out. … High water gives in addition to colour an ever-changing form with a never-known movement … reflection, colour, movement, nothing static or fixed. … [The painting] had to conform to my idea, the walk, so it was long, like the quay, and narrow … in fact I just walked up the canvas with paint.*[23]

There is no question here of the forms and their arrangement being simply generated by rules of geometry, or of the painting as 'an object itself' conforming to a 'rationalist' aesthetic of construction. The description of the genesis of the painting's 'idea' is of an intense experience of 'forms he has seen' and of subjective rapture.

The mode is nevertheless determined (and Frost is emphatic on this point) by the principle that painting should confine itself to the elements proper to it – divisions of the plane, colour and its optical properties, proportion, rhythm and interval, etc. – and through their disposition on the flat surface act upon the viewer by analogy rather than by imitation, evocation rather than description. Frost's contribution to *Nine Abstract Artists,* a book compiled by the critic Lawrence Alloway in 1954, is characteristically down to earth in its description of his approach to making a

painting (it is accompanied by a reproduction of *Black and White Movement on Blue and Green II*, 1951–52, cat. 9, in an earlier stage):

> *I was not portraying the boats, the sand, the horizon, or any other subject matter, but concentrating on the emotion engendered by what I saw. The subject matter is in fact **the sensation evoked** by the movements and the colour in the harbour. What I have painted is an arrangement of form and colour which evokes for me a similar feeling.*[24]

Frost's statement goes on to describe the processes of drawing and printmaking that preceded the final painted image: 'These progressive stages helped me to clarify my ideas, to adjust the various forms to a state of dynamic equilibrium, and to arrive at a final proportion for the canvas.' The purpose of the painting is not to *represent* objects in the visual world but to evoke a sensation in the viewer similar to that experienced by the artist. For the painter it is nature that creates the sensation; for the spectator of the work it is art. But from art we go back to nature, and perceive the world with new vision: the quality of the work is measured by its power to effect perceptual change and a fresh conceptual coherence in our response to nature.

Frost's own vision, that imaginative faculty of bringing what he calls 'the idea' to bear upon the actuality of things, to isolate and identify forms and relations in the welter of the world, is fed by constant observation and by a most intense responsiveness to both art and nature. He is possessed of a preternatural ability to create precise signs that act as triggers to the aesthetic emotion that transforms sensation into an increased knowledge and sense of the connectedness of things. 'It is enough to invent signs,' wrote Matisse. 'When you have real feeling for nature, you can create signs which are equivalents to both the artist and the spectator.'[25] From early on Frost developed a repertoire of recurrent motifs, a distinctive vocabulary drawn from a universal language of marks and figures, geometric and near-geometric, always treated with a joyous graphic freedom, the expressive inexactitude of personal gesture. These perfectly abstract 'signs' – discs, half-discs and quarter-disc segments, circles, chevrons and arrowheads, truncated ovals, lozenges, triangles and diamonds, looping lines, rod-like verticals and stacked horizontal strokes – are deployed in apparently inexhaustible combinations and configurations. The manner (to use the term precisely) of their depiction, and that of the space within which they rock and swing, fly, spin and spiral, float and tumble with such delirious insouciance, is unfailingly quick and sure. Frost's touch has a spontaneous certitude, he is an absolute master of the expressive brush stroke, of the emotive mark and evocative texture.

His play with recurrent forms and motifs, and his virtuosic manipulation of surface colour and texture, constitute what can properly be called the constructive aspect of Frost's art: a process, largely intuitive, of *composing*, of image-building within the confine of the support, conditioned by the 'materials and their existence as form and colour'. It is worth repeating that this process has

fig. 5 El Lissitzky, from *The Story of Two Squares* (written and illustrated by the artist, published Berlin, 1922). 28 × 22 cm

a more than formal significance: this 'dynamic equilibrium' between colour-shapes, tensions of line and stroke on the plane, colour, tone, translucency and opacity are the abstract components of a pictorial drama. Frost has called this 'the myth': it is the 'content' of abstract painting, what replaces the mythological (classical or religious) subject matter of classic post-Renaissance painting. Frost's deliberate use of the term is intended to emphasise that in his own painting what is transformed into signs is the matter of an imaginative response to the world: his art, in creating vivid abstract analogues for particular incidents and events in the artist's everyday life, endows them with mythic significance. This is absolutely at one with Frost's steadfastly materialist philosophy, and with his earthbound wonder at the natural world and its phenomena.

> I've said you make your myth and paint it. My memory is what I rely on. A moment of discovery when I happen to be made aware, or aroused by something I discovered, by surprise: that goes into my store and that becomes my time and space and by the time I use it it's myth that I'm working on. ... What I can't explain is how I get from the story, the memory, the myth, to what I actually make. ... The painting has to stand and fall by itself. Like I said about the Rubens, people have to appreciate the painting without knowing about the myth.[26]

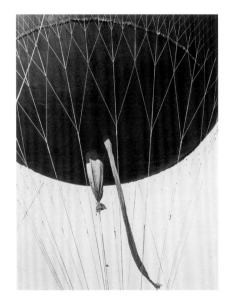

fig. 6 Alexander Rodchenko, *Red Army Manoeuvres*, 1927. Black and white photograph

This must undoubtedly be so; but the dynamic tension that characterises a Frost painting, that quick and sometimes almost uncomfortable vitality of relation between its formal elements, is an aspect of a symbolic drama that communicates immediately as an actual event. This idea of the picture as at once a piece of reality and a mythic construction can be traced to the first 'heroic' generation of abstractionists that Frost has revered since first encountering them, in reproduction, in the late 1940s and early 1950s.

Unlike most artists of his generation, Frost was critically aware of the great (and still neglected) František Kupka, whose early paintings (such as *Discs of Newton*, made as early as 1911–12, fig. 3, and *The First Step* of 1909, fig. 4) are conscious efforts at the painterly enactment of the myth of cosmological creation, and whose discs spinning in space seem to anticipate the imagery of Frost's quasi-cosmic paintings of the 1980s, such as *Dawn* (1987), *Blue for Newlyn* and *Black Olives for Lorca* (both 1989, cats 34 and 35). This is not to speak of subject or style so much as of the governing *idea* that might find various visual realisations. Frost was similarly enthusiastic about El Lissitzky, admiring his invention of a robustly schematic geometric symbolism that could communicate ideas with a vital clarity (fig. 5). In the clarity and lucidity of their forms and colours, and their directness of address to the spectator, works as diverse as *Yellow Painting* (1952, cat. 10), *Red, Black and White, Leeds* (1955, cat. 13), *Red, Black and White* (1967, cat. 28), *Newlyn Rhythms* (1981–88, cat. 33) and *Exclamation Mark* (2000, cat. 39) can be seen to pay frequent homage to the great Russian Constructivist. In Lissitzky especially, it seems that Frost found confirmation of his belief in the 'mythic' potential of an abstract imagery. There is no other congruence of style or purpose.

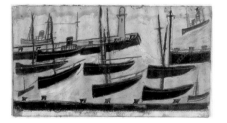

fig. 7 Alfred Wallis, *Nine Ships in a Harbour*, undated. Oil on card, 22.9 × 28 cm. Kettle's Yard, University of Cambridge

Frost's recurrent experiments with construction, his collage of real materials into paintings such as *SS99* (1962–63, cat. 23), and his delight in making or decorating real objects, such as the Tate St Ives Banner (1993) and the plates and dishes he has designed with the ceramicist Colin Haxby, are activities that can all in their different ways be connected back to his love of the Russian pioneers. Frost is natively predisposed to the rational and the democratic, and he has been continuously inspired by the revolutionary Constructivist insights that visual simplicity is a means to the communication of complex ideas and experiences, that art can be made of everyday things, and that art can enter ordinary life at many different levels. 'The Russians,' he once exclaimed, 'El Lissitzky … Rodchenko, they are my gods. It's the discipline of the work which affects me.'[27] Frost was referring particularly to Rodchenko as photographer, and, no doubt, to his use of the unexpected angle of seeing, his extraordinary capacity to catch the visionary moment in an everyday event. Rodchenko's picture of a Red Army balloon (fig. 6), with its black curved form looming into the frame, its tight-stretched strings pulled into chevrons and its freely looping appendage, is typical in this respect; it is, as it happens, a remarkably Frost-like image.

The mystical metaphysics of Malevich's Suprematism, not surprisingly, made no great impression upon Frost. Frost's visual 'myth' is rooted in the physical reality of nature or, rather, in the subjective immediacies of sensational experience: it is not quasi-spiritual but poetic and analogous. 'I am not copying nature, but endeavouring to construct my paintings in the same way as nature, so that they have a trueness about them and a reality as big as nature.'[28] To speak of the 'visionary moment in an everyday event' is to propose that there may be times of particular and special intensity in any given day. In *Walk Along the Quay*, and in those other early paintings of his experience of the harbour at St Ives, Frost found the essential and enduring theme of his work: that we experience the world in space, time and movement, and that our being in the world is to be understood as the enactment of our own myth – 'a reality as big as nature' – discovered in everyday actualities. Alfred Wallis, making his own extraordinary paintings in the same place, may be said to have discovered something very similar, and in his own naïve manner to have prefigured Frost's treatment of the visionary theme (fig. 7). Wallis's unforced truth to reality was exemplary for those artists at St Ives who, like Frost, sought to celebrate in a new abstract language that intensity that Frost himself described as 'a state of delight in front of nature'.

Frost's account of the making of *Red, Black and White 1956* recalls such a state in his reaction to 'a new landscape, Yorkshire under snow'. At the time Gregory Fellow (in painting) at Leeds University, Frost was walking in the hills with Herbert Read:

in snow, so deep it came over the tops of the wellingtons; the angle of the hill seemed about 45 degrees. … It was a clear bright day and I looked up and saw the white sun spinning on the top of a copse. Afterwards and now I recall that I thought I saw a Naples yellow blinding circle spinning on top

fig. 8 Terry Frost, *Arizona Spirals*, 1990.
Triptych: acrylic on canvas, 182.9 × 365.8 cm.
Present whereabouts unknown

fig. 9 Barnett Newman, *Who's Afraid of Red, Yellow and Blue III,* 1966–67. Oil on canvas, 245 × 543 cm.
Stedelijk Museum, Amsterdam

of black verticals. The sensation was true. I was spellbound and, of course, when I tried to look again 'it' had gone, just a sun and a copse on the brow of a hill covered in snow.

It goes on to describe the process by which the experience became art:

so I came back and painted Red, Black and White 1956. *I didn't come back and just paint the picture. I never was able to do that. I never wished to do that. I always have to absorb the moments and then let them go, for I have to make the idea, the discovery. … Sometimes I go for a couple of years before I can get clean as it were and discover the moment again in paint.*[29]

Seeing serried lines of white washing hanging in the closes behind the terraced houses of Leeds provided another such epiphany, as did a drive by car through the Yorkshire hills, experiences that found their way respectively into *Red, Black and White, Leeds* (1955, cat. 13) and *Blue Winter* (1956, cat. 14), transformed as always into vivid abstract signs.

As with much that Frost has to say about his painting, this account may suggest a process of Wordsworthian simplicity: 'a spontaneous overflow of powerful feelings … emotion recollected in tranquillity'. There is, of course, much more to it than that suggests. For a painting has to be made (Frost always speaks of its 'construction') out of actual materials, manipulated to exploit their specific properties. And this process of making is something learnt not from nature but from art. Frost is a master craftsman, but his is an art that often conceals art, as if the spontaneity of his expression were somehow, like Wallis's, simply given. Not so; from the moment he heeded Pasmore's advice, and took himself to study at the National Gallery, Frost's distinctive abstraction has been carefully and consciously developed. He has looked with an intelligent and passionate eye at the art of the past and of his own time, taken and assimilated what he needed to create an art rooted in the phenomenal. His idea of the visionary does not extend to metaphysics or have any cast of the religious to it. His critical consciousness of the underlying nature of his creative purposes (at once technical and philosophical) is at times revealed with a knowing irony. The glorious repeated motif of *Arizona Spirals* (1990, fig. 8), for example, creates the simple music of an inspired song celebrating the energy that informs all things natural: 'spirals are forever'. The transcendental claims of Barnett Newman's monumental *Who's Afraid of Red, Yellow and Blue III* (1966–67, fig. 9), its insistent demand on the spiritual, its grand address to Mondrian's magisterial advocacy of absolute values beyond natural contingencies, is playfully mocked by Frost's insouciantly material answer to its question. Frost's painting is fearlessly committed to light and colour as aspects of the natural, to the unceasingly marvellous *perpetuum mobile* of the world; it is dedicated to the turning of sun and moon, the wheeling of the heavenly bodies, and to the elemental actualities of earth, water, air and fire.

Notes

1 Quoted in *Terry Frost*, ed. Elizabeth Knowles, Aldershot, 1994, p. 168.

2 Adrian Heath, 'Recollections and Movements', in *Terry Frost: Painting in the 1980s*, University of Reading, 1986, p. 13.

3 Ibid., p. 13.

4 *The Townsend Journals*, ed. Andrew Forge, London, 1976, p. 77.

5 Knowles, ed., 1994, p. 40.

6 Ibid., p. 40. Since ancient times the Three Graces have been seen as personifying the virtues of 'giving, receiving and giving again' (giving, accepting and returning); see Edgar Wind, 'Seneca's Graces', in *Pagan Mysteries in the Renaissance*, London, 1958.

7 Knowles, ed., 1994, p. 40.

8 Patrick Heron, 'London: Alan Davie and Terry Frost', *Arts (NY)*, April 1956; repr. in *Painter as Critic: Patrick Heron: Selected Writings*, ed. Mel Gooding, London, 1998, p. 107.

9 Ronald Alley, 'Introduction', in *Victor Pasmore*, Tate Gallery, London, 1965.

10 Knowles, ed., 1994, p. 45.

11 Ibid., p. 56.

12 Kenneth Martin, in *Broadsheet No. 1*, published to accompany the exhibition 'Abstract Art' at the AIA Gallery, London, in 1951.

13 Quoted in Norbert Lynton, *Victor Pasmore: Nature into Art*, New York, 1990, p. 22.

14 Knowles, ed., 1994, p. 44 (my emphasis).

15 Ibid., p. 44.

16 See n. 12 above.

17 Knowles, ed., 1994, p. 42.

18 Adrian Heath, in *Nine Abstract Artists*, ed. Lawrence Alloway, London, 1954, p. 25.

19 Anthony Hill, in Alloway, ed., 1954, p. 28.

20 See n. 6 above.

21 Fernand Léger, 'The Origins of Painting and Its Representational Value', 1913; repr. in *Functions of Painting*, ed. Edward F. Fry, London, 1973, p. 3.

22 Martin, in Alloway, ed., 1954, p. 31.

23 Knowles, ed., 1994, pp. 48–9 (my emphasis).

24 Frost, in Alloway, ed., 1954, p. 23.

25 Henri Matisse, 'The Path of Colour', 1947; repr. in *Matisse on Art*, ed. Jack D. Flam, Oxford, 1973, p. 116.

26 Knowles, ed., 1994, p. 169.

27 Ibid., p. 170.

28 Frost, notebook, Yorkshire, 1956.

29 Knowles, ed., 1994, p. 66.

Memory and Imagination

The following observations by Terry Frost about his paintings in the exhibition are drawn from a conversation with Isabel Carlisle that took place at the artist's home at Newlyn, Cornwall, in April 2000

Chronology

Memory and Imagination: 1941–1959

The War Years: [On the front line] your sensitivity to every blade of grass becomes important. Every person becomes important, every way in which a leaf hangs off a tree. Every flower has its own personality in the form that it makes. The earth always looks a different colour by each green. And the green looks different by each red. That's the kind of observation that knocked me out when I first started [as a painter]. Walking through a garden when I got back to England I would see all these different colours. It's discovery every day if you want.

> In prisoner-of-war camp … I got tremendous spiritual experience, a more aware or heightened perception during starvation, and I honestly do not think that that awakening has ever left me. There are moments when I can tune in to the 'truth', contact the other part of us and nature.[1]

If you are in a forward position, eight of you in front of the first line of troops, your observation has to be spot on in order to establish the range. You want to know the distance between here and that tree. So I looked, and saw all these birds up a tree, which was wonderful. I wrote home about it and I must have gone over the top, they thought I was mad. I wasn't trying to be clever, it just was an experience that I hadn't had before: I had never seen such a crowd of chattering jays.

Door in Wall, Beaufort Street, 1946–47, cat. 1
You can see all the spaces in between the solid forms. I think that [the Camberwell] kind of painting, for me, was quite a good lesson: the discipline of it is how you learn. I had been painting a still-life at the School of Art for about six weeks and I think Coldstream had spoken to me only twice in twelve months. Because I admired him I was determined to get him to talk to me. So, very bravely, I got him to look at my painting of a fern with a classical head behind it, the green and the white. I had really worked on that, every stalk of the fern and he just said, 'Well, if I was you, I would just scrape it out and start again.'

The Chair, 1947, cat. 2
I did this painting by the light of an electric light bulb between midnight and three in the morning. Matisse would have been pleased with that bit of chair.

Mrs Pollard, Eddy and Cocking, Back Road West, St Ives, c. 1947, cat. 3
I lost the top of the painting because I cut if off to use for something else: the island was there [the promontory of land between the two bays in St Ives]. They were very good, all my neighbours, they always came out for a chat in those days. They weren't bed-and-breakfasting then, their husbands were still out fishing.

Battersea Park, 1947, cat. 4

On Mondays at Camberwell we had composition classes and we were once asked to do something with six figures in. So when I took my son Adrian out in the pram to Battersea Park I was observing people and I made up the six figures from my sketches, with Albert Bridge in the background.

Miss Humphries, 1948, cat. 5

I know I had been drawing her [Miss Humphries, life model at Camberwell] for about six weeks, most of us had because she was such a good model. I had all these drawings in my notebook and I set about trying to do the painting because I must have read that great artists painted from drawings. And of course it was quite a shock because I then learnt that I hadn't got all the necessary information about where all the spaces were, all the softness and hardness, so I had to do a lot more thinking. I had to work like hell to think the spaces and to think the softness and hardness. But it taught me to draw, to learn my own shorthand in order to get all the information.

Self-portrait, 1948–49, cat. 6

That's rather nice, the stained-glass window making a halo of flowers round the head. I had a beard then because Victor Pasmore was my god, so I had to have a beard too. The real problem I was solving in this portrait was how to use warm and cool to make forms, so I put a bit of Indian red on the nose and a bit of green on the ear, which seemed an obvious way of making space without thinking just in terms of tone. Colour theory tells you that warm colours come forward and cool colours recede, that's about as useful as it is.

Madrigal, 1949, cat. 7

I was trying to do what Claude Rogers had set us to do as a summer project, which was to choose between 'Joseph's Coat of Many Colours' and 'A Madrigal'. I found all the experts disagreed what Joseph's coat was about, so I looked in a book of poetry and found 'Madrigal' by W. H. Auden, part of which goes:

> O lurcher-loving collier, black as night,
> Follow your love across the smokeless hill;
> Your lamp is out and all the cages still;
> Course for her heart and do not miss,
> For Sunday soon is past and, Kate, fly not so fast,
> For Monday comes when none may kiss:
> Be marble to his soot, and to his black be white.

I just made the painting, the first abstract that I showed, happen according to my intuitive reaction to the poem. I was using a rectangle and appreciating a flat surface, all in tonal Camberwell colours. The diagonals make the slag heaps, the dark colours the mine, and light when the collier came up for lunch.

1947–50 Attended Camberwell School of Art on an ex-serviceman's grant, commuting between London and Cornwall. William Coldstream was head of painting, assisted by Claude Rogers, Victor Pasmore and Lawrence Gowing.

1947–64 Terry and Kathleen lived in a cottage in Quay Street, St Ives, where all six children were born: Adrian (14 July 1947); Anthony (4 May 1951); Matthew (24 September 1954); Stephen (28 December 1955); Simon (13 February 1958); and Kate (9 June 1964).

1950 Terry Frost and his family move permanently back to St Ives. Worked as an assistant to Barbara Hepworth on Contrapuntal Forms (1951), a large two-part sculpture in blue Connemara limestone commissioned by the Arts Council for the Festival of Britain.

1951 Took one of the Porthmeor studios at St Ives, adjacent to Ben Nicholson's. Showed in an 'Abstract Art' exhibition at the Association of International Artists Gallery, London; also at Gimpel Fils and in New York in the exhibition 'Danish, British and American Abstract Art'. Visited Paris for the first time.

1952 Frost's first one-man exhibition at the Leicester Galleries. Began teaching at the Bath Academy of Art at Corsham Court.

Walk Along the Quay, 1950, cat. 8

The walk through space [as] an experience and not a window perspective thing at all,
it was a Time experience.[2]

When I was walking along the quay I was looking down at things, I wasn't trying to be clever. It's unusual to be looking down at your feet as you're walking along: it keeps the landscape on a flat surface. I marked the canvas out geometrically before I started. There is sky at the top, then a meeting of sea and sky. At the bottom there is a little bit of still water where the boats are moored up. Ben Nicholson came and looked at *Walk Along the Quay* at my home at 12 Quay Street for about two hours, the longest he had ever stayed. I gave him a sandwich, which was very unusual for Ben to accept. I was thrilled, even though he didn't say anything.

Black and White Movement on Blue and Green II, 1951–52, cat. 9

The Golden Section is in here. All the curves are made by dropping the string that had been used to draw the lines, so every shape has a relationship to some other geometrical measurement. There is that kind of basic structure through the canvas. At this time I was more concerned about the division of the area than about movement: about having total control of the still-life. You can be as abstract as you want if you have your structure. Getting structure with colour is a totally different thing. Once that is in, it can totally destroy the shape.

Yellow Painting, 1952, cat. 10

The only way I got back to painting after working for Barbara Hepworth was through small constructions and collage. I had to make a shape. It was almost alarming to realise that all my paintings on a flat surface were an illusion.

The Golden Section is in here again, and wedge-shaped areas that make the painting jammed tight. The little bits of frivolity are my bit of fun. Those spirals are there because I was trying to stick my coloured shapes on and they fell off: the glue was a black kind of bitumen stuff which I put on in a spiral.

I had been building constructions in which I used bamboos, so the lines in the painting are all structure, or supports. [Peter] Lanyon had been doing constructions from [Naum] Gabo's influence, Johnny Wells had been doing constructions and I had been working for Barbara. I had met Gabo and I fell in love with Russian Constructivism, so it was only right that I should use structure. I learnt so much at that time with Lanyon, Nicholson, the Gabo influence, Barbara Hepworth: the professionalism, the attitude to work. You don't waste your paper, you don't waste anything. But you use paint like Colman's mustard, you waste more than you use.

I was so happy doing what I promised myself I would do when I was a prisoner of war, which was a complete change of life. There was an innocence at that stage. One was so glad to be able to do art – and the jealousy, friendship, envy, comradeship were fantastic. If you see someone doing a better painting than yours after you've walked through the same landscape, it drives you mad.

1953 *Patrick Heron included Frost, Heron, Hilton, Lanyon and Pasmore in the exhibition 'Space in Colour' at the Hanover Gallery, London.*

1954–56 *At Leeds University as Gregory Fellow. Moved to Yorkshire with his family.*

1956 *In January Frost visited the exhibition 'Modern Art in the United States: A Selection from the Collections of the Museum of Modern Art, New York', with works by Pollock, De Kooning and Rothko, when it was shown at the Tate Gallery in London. This important exhibition was to influence a whole generation of artists, Frost among them.*

1956–57 *Taught at Leeds School of Art.*

1958 *Frost returned with his family to St Ives.*

Nobody thought we were a group. We had continual arguments, pretty vicious at times. We knew we were in a kind of avant-garde for abstraction because people came from all over the world down here [to St Ives], they didn't even bother to stop in London, up till about 1959. But I never stopped to think about it. I was asking myself whether I could make enough money to keep the children and whether Kath could stop making beds at St Christopher's Hotel. The question was: could I get out of working for other people? It was as simple as that. Nobody started to think of us as a group until Patrick Heron wrote about us, and he was the best critic there was at that time, writing for the *New Statesman*.

Red, Black and White, Leeds, 1955, cat. 13

The first-year Leeds University architectural students invited me to give a talk. I wanted to kill the idea of architecture as decoration stone dead – architects placing coloured doors and palm trees in interiors and thinking that was decoration – so I gave them an exercise to work on, which was to create a screen in a canteen so you don't see all the greasy stuff, and this design would affect the tables and everything. So before I went in I did a collage like that for a simple panel. It got me working with red, black and white, which was simple. I then did a painting of it and the painting was related to the fact that I was no longer in Cornwall.

Here down in Cornwall I can see the moors on three sides and the sun and the moon. But when I went out on to Ilkley Moor I suddenly felt no longer a giant but just a little tiny person, faced by Goredale Scar and other scars flat up in front of me. It was an honest solution to painting landscape on a flat surface, because that was what it looked like.

Leeds Painting II, 1954–56, cat. 11

I used to wind up the engine of my Bedford van on the cold, damp mornings in Leeds to make it start. Then I would look up and see the octagonal shape around the sun above the verticals of the trees. When you are out walking you can look up and be hit visually by a copse or a lot of trees that shape. You are walking through poetry really. The shape in this painting was all linked up with the movement of what I was doing: it became part of me at that time, whether it was the pleasure of being in the landscape or the exhaustion of not being able to start the old van. I think I have been more influenced by poetry than I realise.

Blue Winter, 1956, cat. 14

This painting is about driving home from Harrogate, with the landscape on my right. It was white with a beautiful blue moon: it had been snowing. Luckily it was very late and there was no other traffic, so I was able to take it in as I was driving. Here is my blue moon at different stages, and the landscape, which I am still treating as in *Red, Black and White, Leeds*. I didn't make notes. When you come to paint you're just with the blank canvas. Your first mark is going to be nothing like that dream and wonderful moment. It's great if you do suddenly hit what you were thinking about.

Yellow Triptych, 1957–59, cat. 12

This painting represents another new experience. The painting was done in Leeds. I had the hardboard, which was cheaper than canvas, 8 feet by 4 feet as they are. I had to prepare them and I got the titanium white from ICI, half hundredweight bags at a time. That's in all that yellow, to lift it up and give it the power. I hadn't got a studio and was living in a rented house. The painting is the size of the wall in the bedroom that I used as a studio. I couldn't step back far because I had tins of paint all over the place. I suddenly realised I was painting in a different way from easel painting, right up to it. It meant that I was working from my concepts, very close to the idea: it's about thought rather than walking back to see it.

Black Wedge, 1959, cat. 15

I get a chance to use interesting colour here, and it's lovely to try and do that squeeze of colours, yet keep it flat. I used wedges a lot to tighten up form and I still knock them in occasionally. If you've got tightness on a flat surface, the structure is a certainty, it can't fall apart. There was a great domination of Moore and his lying-down things and I think this painting is a bit to do with reclining form.

Winter Nude, 1959, cat. 16

This is a very sexy little nude. There always was that side of me. I have to face the fact that I was a terrific flirt. I think Hilton and I were having arguments about the figure at that time, and Lanyon had [also] done a few figure paintings, so there was a bit of a battle on. I was trying to stick to abstraction, but occasionally my romantic side, my love-making side would take over.

The white is because I just wanted to make it lovely. It is not pornography or anything like that, it's a love side. It's very simple, the chevrons and wedges are all part of the figure. The chevrons become nipples very often, and then the penetration is a chevron as well, in a nice way. The trouble in this country is that no one can admit honestly that they enjoy sex.

1 Frost, 'Notes, Banbury mid-1960s', in *Terry Frost: Paintings in the 1980s,* University of Reading, 1986.
2 Frost, lecture notes, 1955–56.

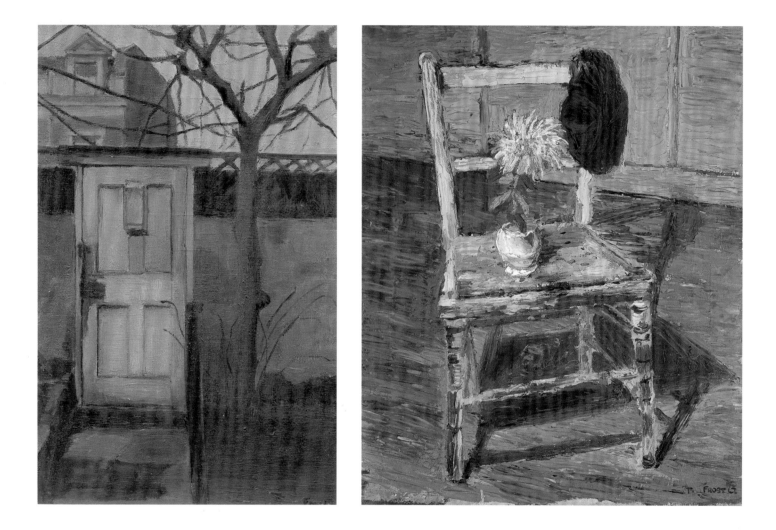

1 **Door in Wall, Beaufort Street**, 1946–47. Oil on board, 26 × 17.5 cm. Private collection
2 **The Chair**, 1947. Oil on canvas, 61 × 50.8 cm. Collection of the Artist

3 Mrs Pollard, Eddy and Cocking, Back Road West, St Ives, *c.* 1947. Oil on board, 43.2 × 74.3 cm. Private collection, courtesy Belgrave Gallery

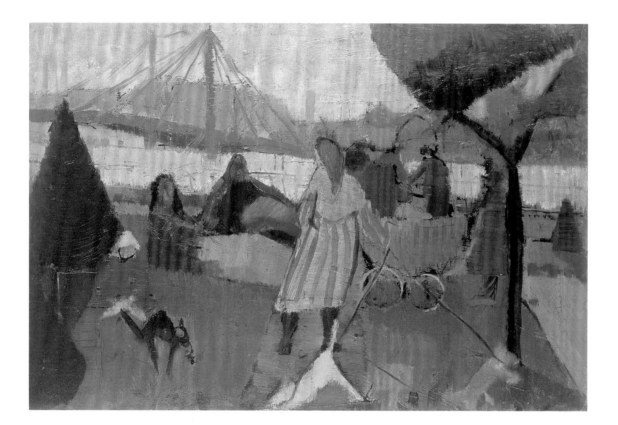

4 **Battersea Park**, 1947. Oil on board laid on panel, 30.48 × 45.72 cm. Private collection, courtesy Belgrave Gallery

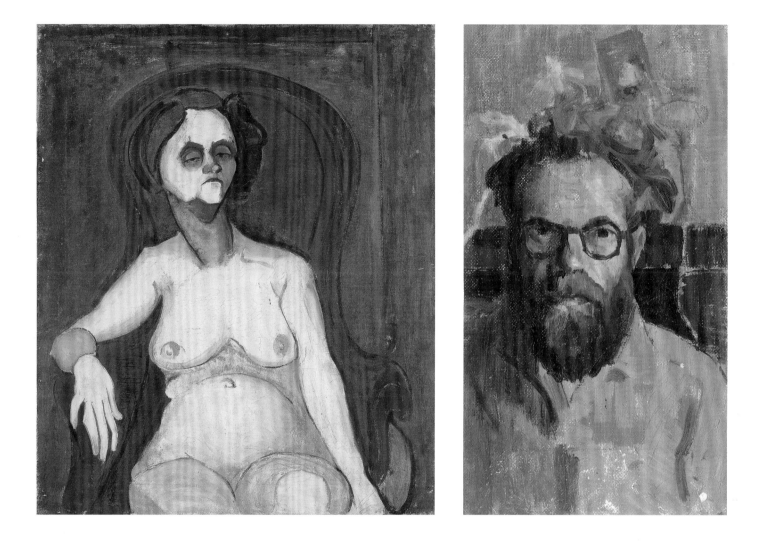

5 **Miss Humphries**, 1948. Oil on canvas, 76.2 × 63.5 cm. Collection of the Artist
6 **Self-portrait**, 1948–49. Oil on canvas laid on board, 45 × 25.4 cm. Private collection, courtesy Belgrave Gallery

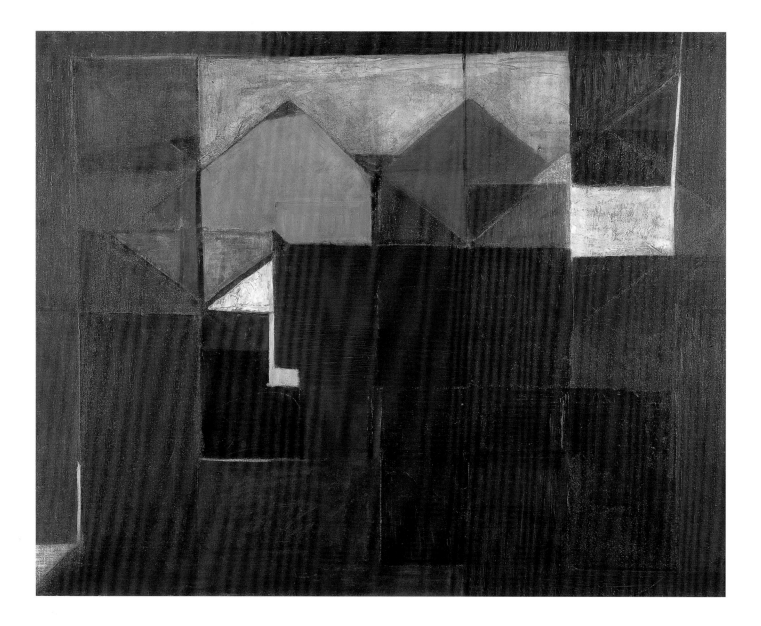

7 **Madrigal**, 1949. Oil on canvas, 71 × 91.4 cm. Leamington Spa Art Gallery and Museum, The Royal Pump Rooms (Warwick District Council)

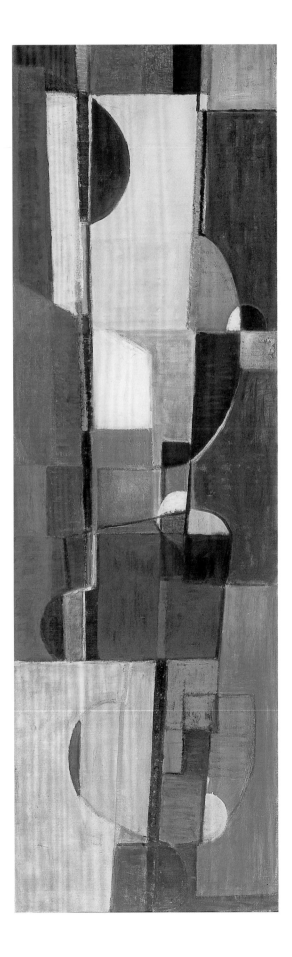

8 **Walk Along the Quay**, 1950. Oil on canvas, 152.5 × 56 cm. Private collection

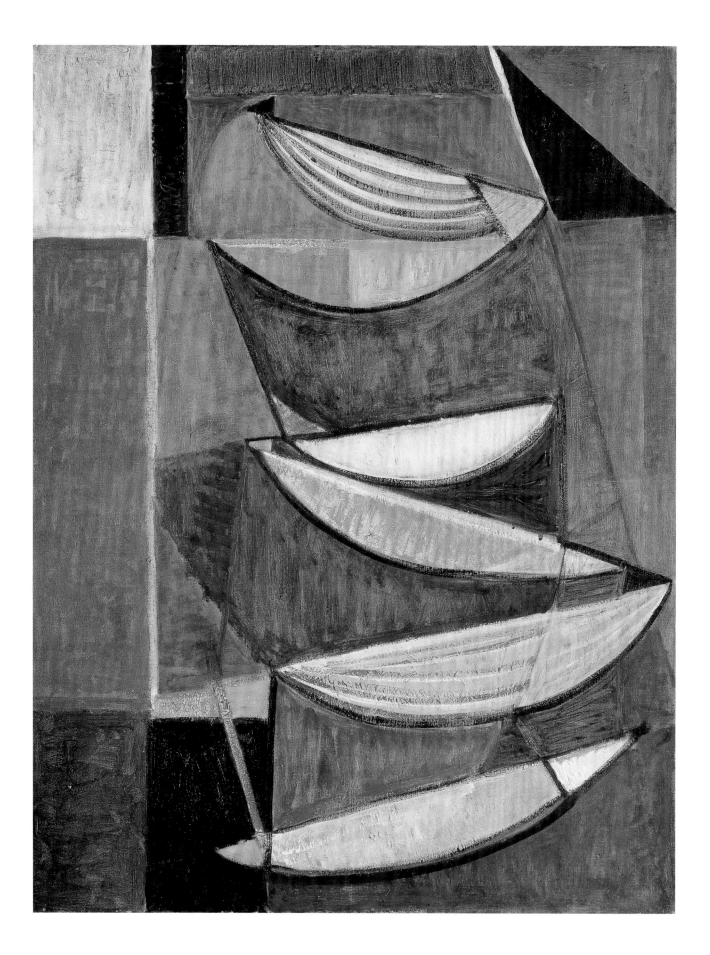

9 Black and White Movement on Blue and Green II, 1951–52. Oil on canvas, 111.8 × 86.3 cm. Scottish National Gallery of Modern Art, Edinburgh

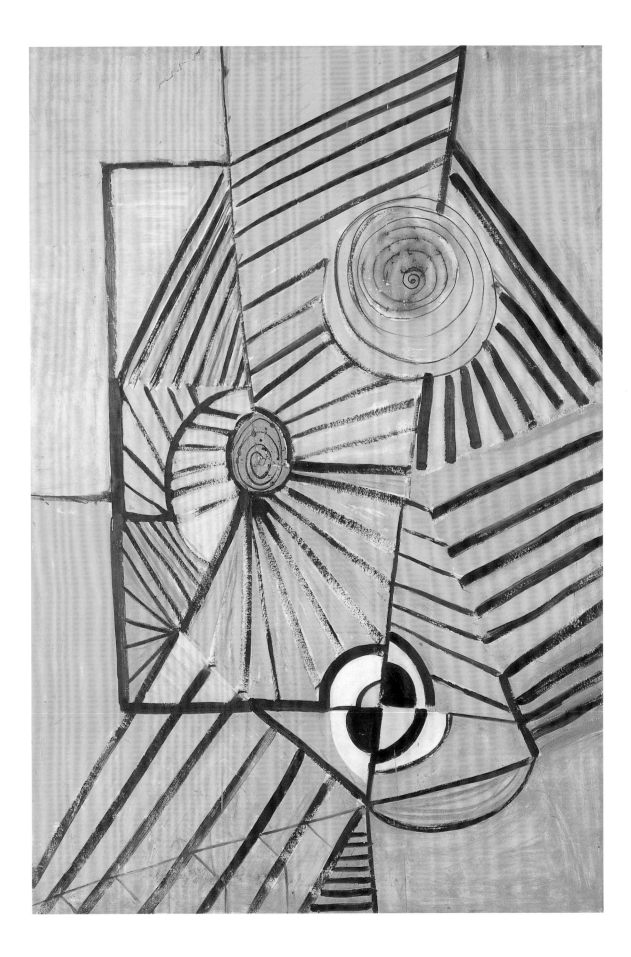

10 **Yellow Painting**, 1952. Oil and collage on board, 176.5 × 122 cm. Private collection

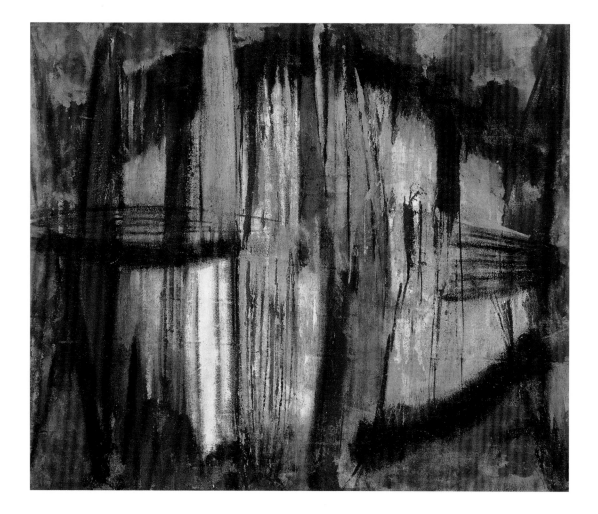

11 **Leeds Painting II**, 1954–56. Oil on hessian, 167.6 × 182.9 cm. Private collection

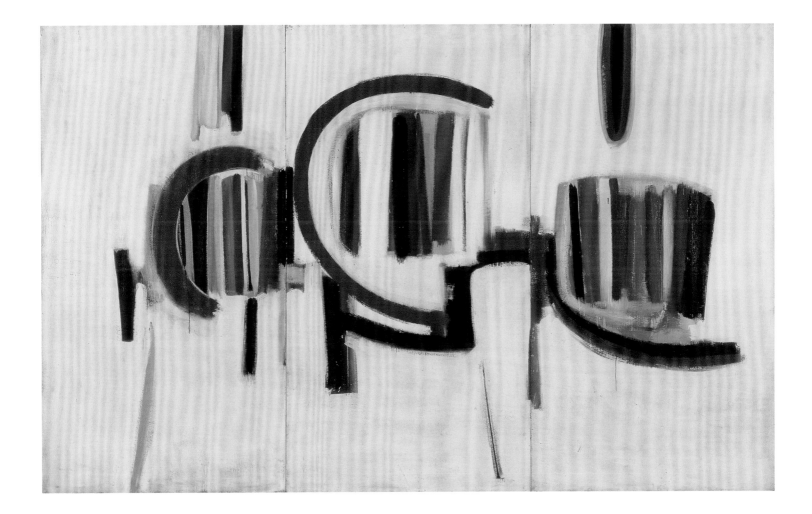

12 Yellow Triptych, 1957–59. Oil on board, 228.5 × 365.8 cm. Tate, London 2000

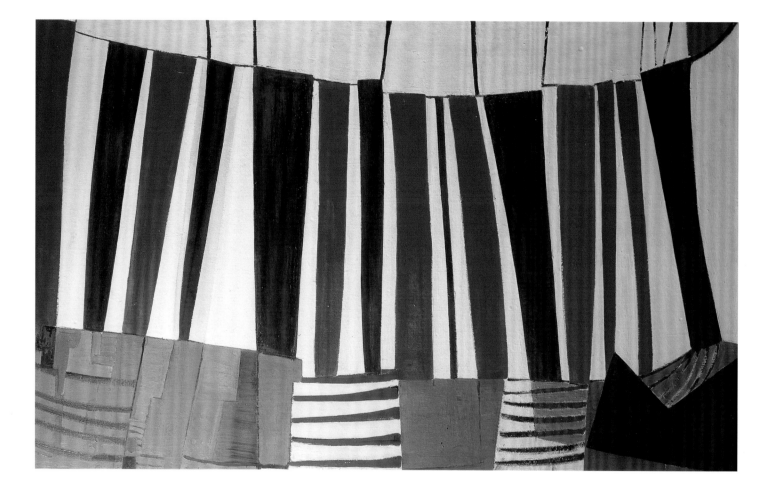

13 **Red, Black and White, Leeds**, 1955. Oil on board, 122 × 182.8 cm. T. L. Johnson

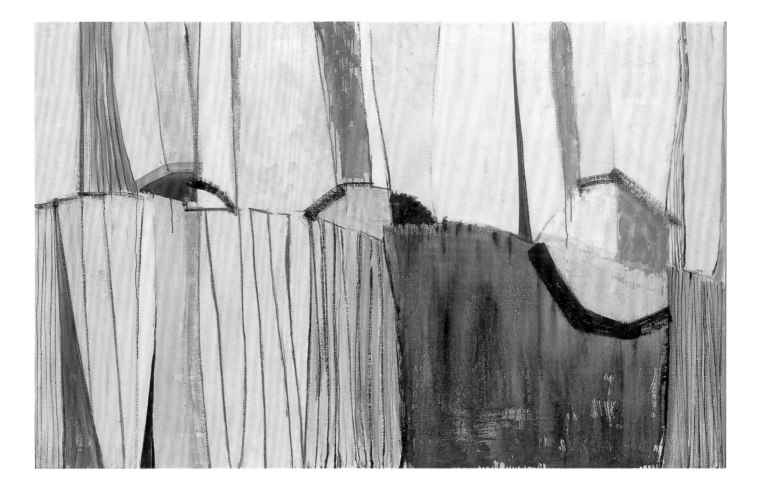

14 Blue Winter, 1956. Oil on board, 121 × 190.5 cm. The British Council

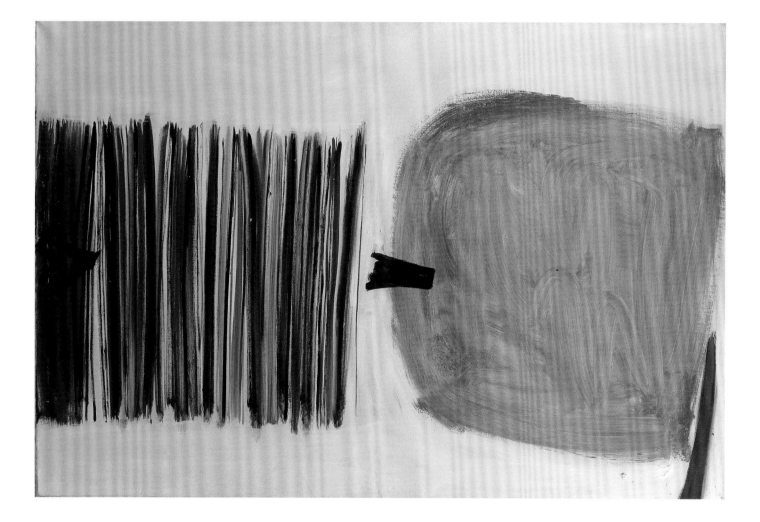

15 Black Wedge, 1959. Oil on canvas, 104.14 × 154.94 cm. Private collection

16 **Winter Nude**, 1959. Oil on canvas, 50.8 × 61 cm. Private collection

1960 *Solo exhibition at Waddington Galleries, London.*

1960 *Frost went to New York for his first American one-man show in Bertha Shaefer's gallery. There he met the Abstract Expressionists De Kooning, Frankenthaler, Motherwell, Newman, Rothko and Kline and visited some of their studios.*

1962 *Frost was asked to do the lettering for a boat in St Ives harbour called the SS99 (SS denotes St Ives).*

1962 *Frost and his family moved to Banbury. Became part-time teacher at Coventry School of Art.*

1963 *Frost in Whitechapel group show 'British Painting in the Sixties'.*

1964 *Frost was invited to teach a summer course at the University of California at San Jose. For six months he was also Artist in Residence at the Fine Art Department of Newcastle University.*

1965 *Frost appointed full-time lecturer in the Department of Fine Art, Reading University.*

Memory and Imagination: 1960–1969

Three Graces, 1960, cat. 17

The vertical stripes are speed against the weight, and lightness against the weight. When I copied Rubens's *The Judgement of Paris* (National Gallery, London) during my student days at Camberwell I learnt so much from glances and the use of three reds, light and shade, speed and slowness, softness and hardness. The glances of the girls make the most wonderful Analytical Cubist form. At the same time I was very much in love with the Rembrandt, which was in a smaller room at the National Gallery, where she is lifting her night shift up [*A Woman Bathing in a Stream*]. He has ochre and blue on the same brush stroke, he must have picked them both up together. So the *Three Graces* was really based on the Old Masters.

Force 8, 1960, cat. 18

There happened to be a gale one day when I went to the studio, up against the sea in St Ives [on Porthmeor Beach], where you really get belted by the sand and the sea. It really is quite frightening, and exciting. I had a little radio on which they said it was a Force 8 gale, so I entitled my painting *Force 8*. I painted to the sound during the whole of the gale and it really made me hit the strokes. The wedges take hold of the whole thing and tighten it like a spanner. I have used suspended forms here [down the canvas on the left-hand side]. Also, the colour is very interesting because it allows the canvas to come through. Different weights, different speeds, different thrusts – all what a gale is like.

Three Forms, 1960, cat. 19

When you are young you are always told that two's company and three's a bloody bore. I used to like that challenge of putting three things on when everyone thinks two is easier. You have your horizontals and verticals and penetration coming in from the side, but it is all locked together.

All the people I met at that time at the Cedar Bar Tavern in New York's Greenwich Village, including De Kooning, Kline and Larry Rivers, were interested in what I was doing. I think they were good to me because they knew I had a return ticket. Clement Greenberg was fantastic: he showed me all his paintings (he was quite a good artist) and his collection of David Smith's sculpture, and he also showed me the first targets of Kenneth Noland and a wall of Olitskys. I brought away from those artists a strong professional attitude and the courage to do large paintings and the courage to cut out the bit that you like and throw the rest away.

Blue Linen Figure, 1960, cat. 20

The use of collage can depend on liking the colour of the canvas. You make a form when you cut the canvas, you are taking a positive decision, like with this great wedge. That is a good structure which I used in the *Three Graces*.

Laced Grace (prototype), 1962, cat. 21

The dealer Leslie Waddington said 'Can't have that, it looks like a chastity belt', but he bought the painting all the same and sold it on. I did the lacing first in charcoal, which was easy, but when it came to cutting holes in the canvas for the boot laces it was not so easy. Then I slit the canvas and I solved the problem of how to cross the laces. The chevrons running in a line up the top of the picture are vertebrae. The laced forms are related to my sexual ideas, and to Mae West.

M17, October 1962, 1962, cat 22

That is a snorter, I am proud of that. This was a deliberate effort on my part to find out for myself what was going on. I think it was the critic of the *Daily Mail* who first saw road traffic signs in my painting. You used to see a lot of them in Banbury, because lots of people go through it on their way somewhere else. I thought, with this criticism, why don't I do all the signs I have seen on one canvas? So you have everything on there I have ever done.

SS99, 1962–63, cat. 23

I was told I was bad at lettering at school, so I made these S and 9 shapes mainly from drawing round circles. I practised them with my black ink, and made those cut-out shapes, but in the end I had to get Dennis Mitchell to do the lettering on the boat *SS99*. Then I used the shapes on the picture, as collage. [The image] is also to do with the fact that my grandmother used to have corsets that she would ask me to lace up.

September 1964, 1964, cat. 24

I went to San Jose and travelled through the desert and saw colours of this kind. They gave me acrylic in San Jose, and that is why I started using it after that, but this is still in oils. I like drawing on the canvas. [This painting shows] those thin lines I started using in 1954; it takes a bit of doing to retain them. There are half moons, quarter moons and much more in there.

Mae West, *c.* 1965, cat. 26

I had always done constructions, one or two a year, because I always wanted to be a sculptor, and a painter, and a potter. I couldn't do all those things but I had always done constructions, mainly small things. So I did *Mae West* small and then I got it enlarged by the woodwork department at Reading University. It's made of stretched canvas glued onto the wood. The title came after it was made. I called it *Mae West* because it's big at the front, it's as simple as that.

Spring, 1966, cat. 25

[In 1964] I had been in Newcastle, where I had a six-month fellowship and was given a studio. Schwitters was the big thing up there, and I did a lot of walking about in a new landscape. I also took the colour course for the first-year students in conjunction with Richard Hamilton. In this painting the chevrons are going out and supporting the central figure instead of penetrating.

Construction, 1966, cat. 27

In Banbury there was a furniture shop that threw away lots of wood shapes that had been cut out from furniture. They happened to be those semicircles and my son Anthony, as he came home from school, saw them and picked them up. When I wanted to do a big one I had to have the wood cut for me. And then I learnt to put the canvas round. My mother was a dressmaker, so I learnt how to cut on the bias. It's interesting to put your flat shapes into a sculptural form, quite exciting to see what happens.

Red, Black and White, 1967, cat. 28

[By the mid-1960s] I knew I had to do some large paintings, for my own sake: maybe I was ambitious to go to the States; it is essential to find out what can happen when you work big. I had done *Red, Black and White* small and I wanted to do it again on a scale that would really surround you. At that time in my life I could paint on the floor, so I would stand to make semicircles which were drawn by my body. You couldn't do that on an easel because you would plan it too much if you did. [In mixing the colours] you move your white, move your red or move your black to the magic touch between them, the warm and the cool.

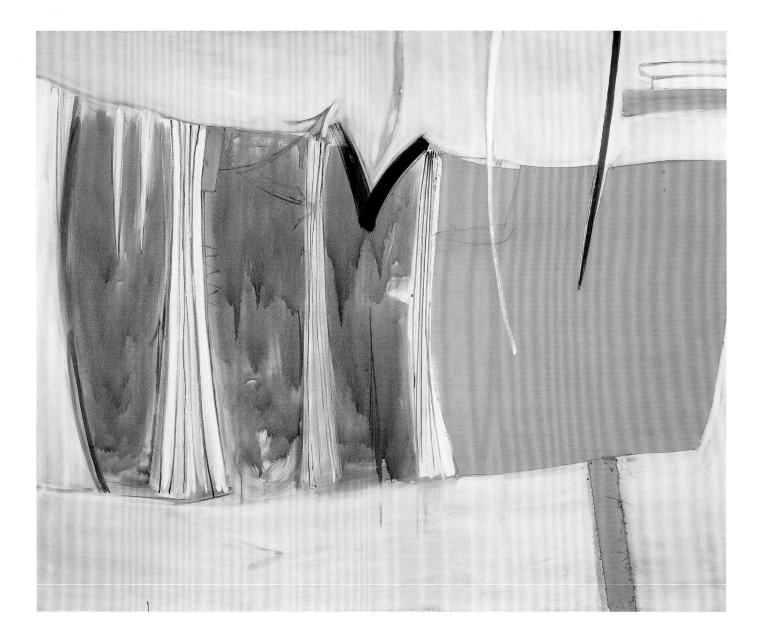

17 Three Graces, 1960. Oil, collage and charcoal on canvas, 198 × 243.8 cm. Bristol Museums & Art Gallery

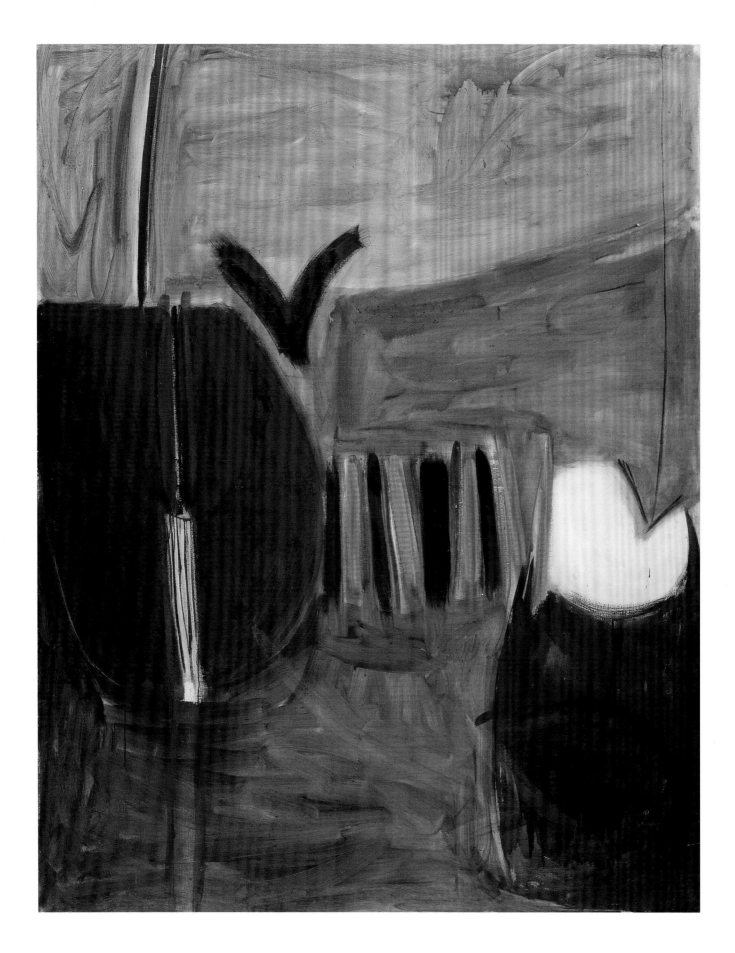

18 Force 8, 1960. Oil on canvas, 221 × 173.4 cm. Ferens Art Gallery: Kingston-upon-Hull City Museums and Art Galleries

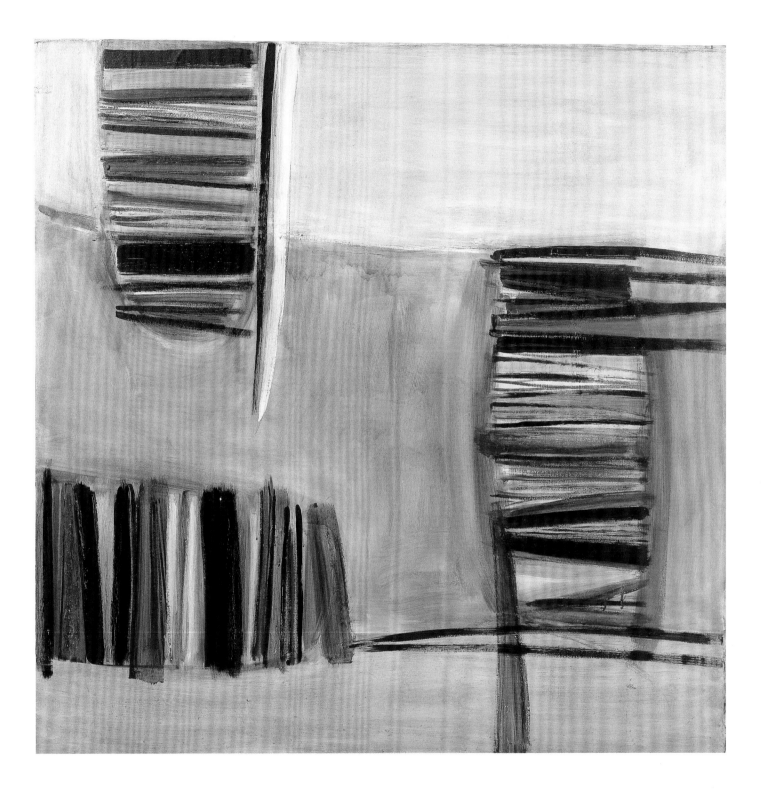

19 **Three Forms**, 1960. Oil on canvas, 122 × 122 cm. Private collection

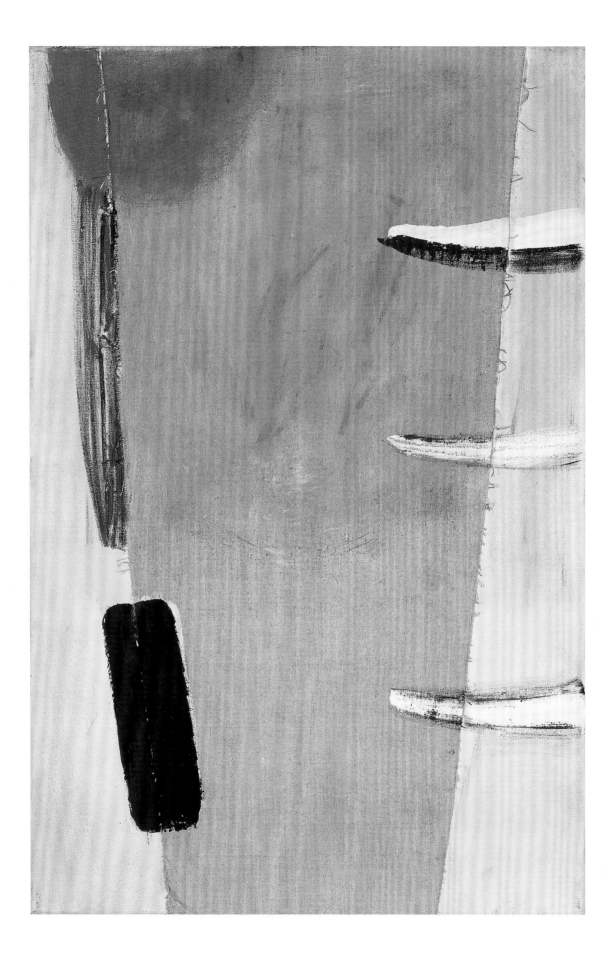

20 **Blue Linen Figure**, 1960. Oil on canvas, 61 × 41 cm. Private collection

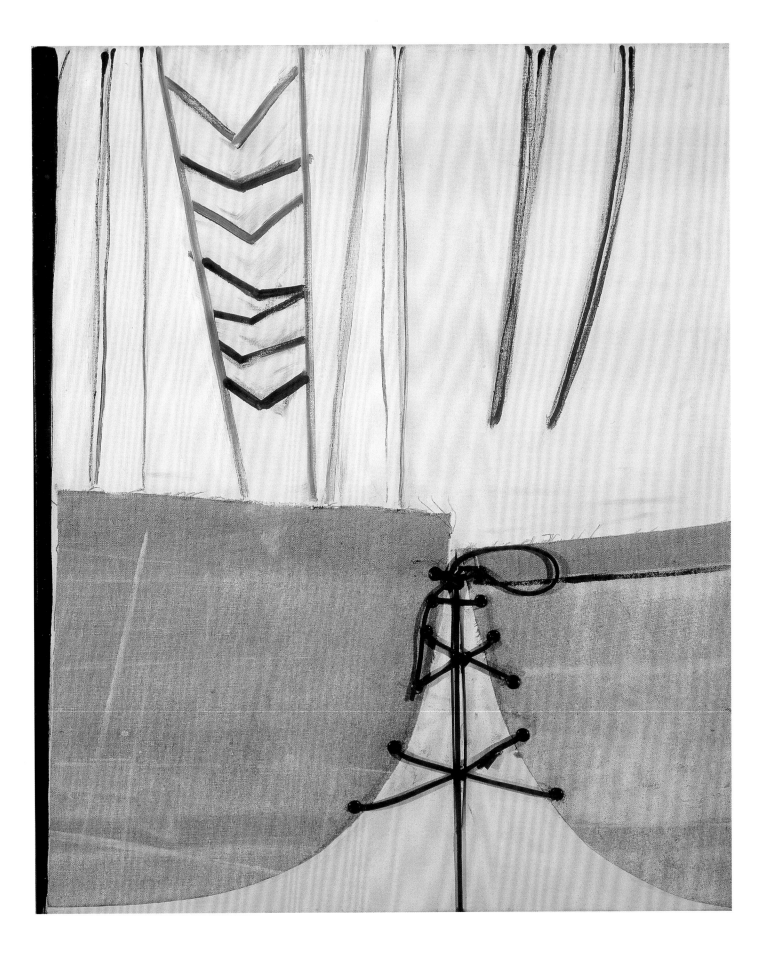

21 **Laced Grace (prototype)**, 1962. Oil and collage on canvas, 61 × 50.8 cm. Private collection, courtesy Belgrave Gallery

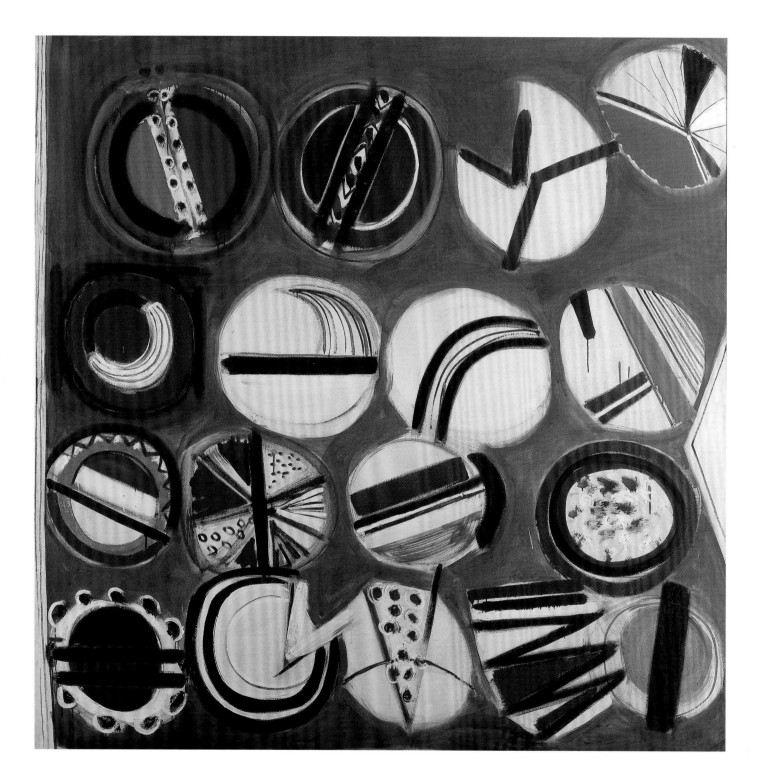

22 M17, October 1962, 1962. Oil on canvas, 182.9 × 182.9 cm. The British Council

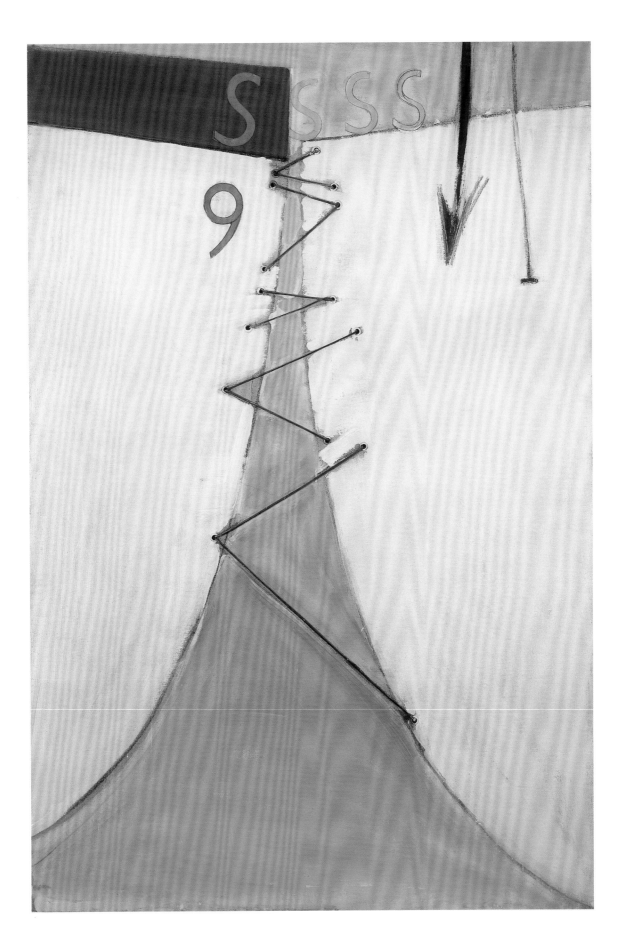

23 SS99, 1962–63. Oil and collage on canvas, 152.3 × 102 × 2.2 cm. Private collection

24 **September 1964**, 1964. Oil on canvas, 152.5 × 91.5 cm. Private collection

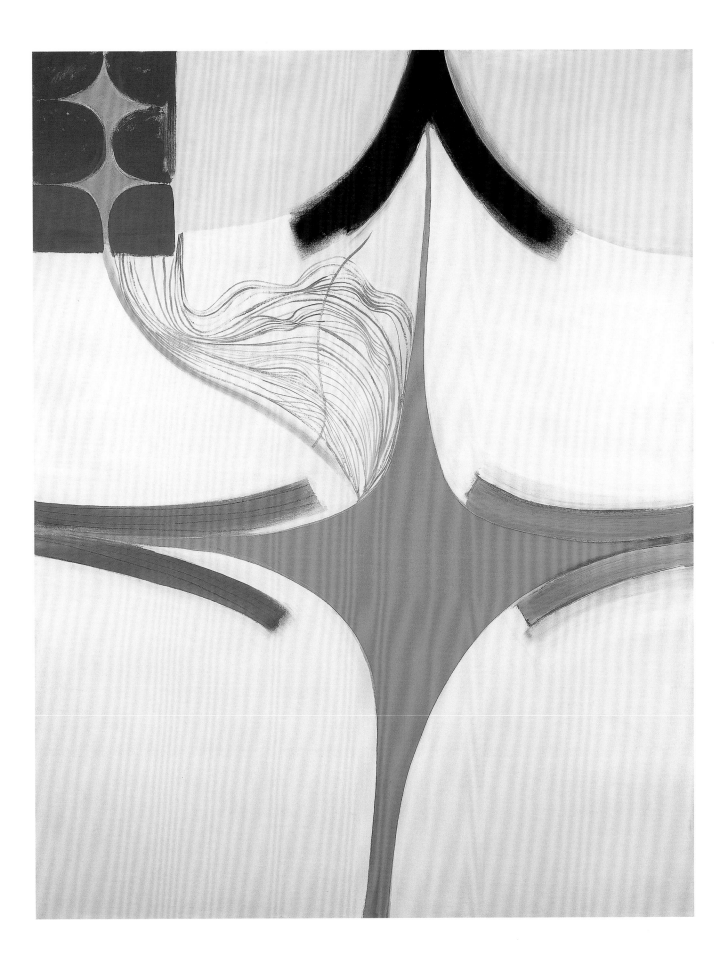

25 **Spring**, 1966. Acrylic on canvas, 220.98 × 172.72 cm. Collection of the Artist

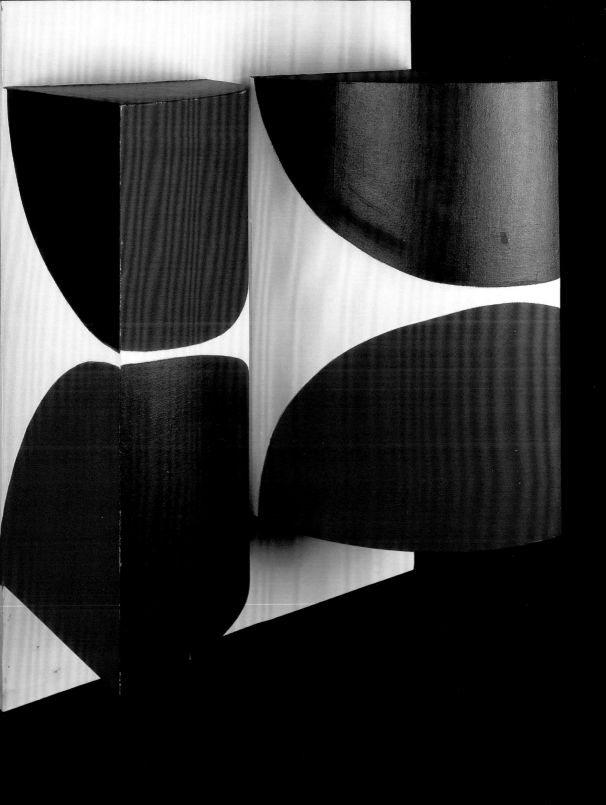

Mae West, c. 1965, oil paint and wood on canvas, 121 x 98 x 46 cm, Collection of the Artist

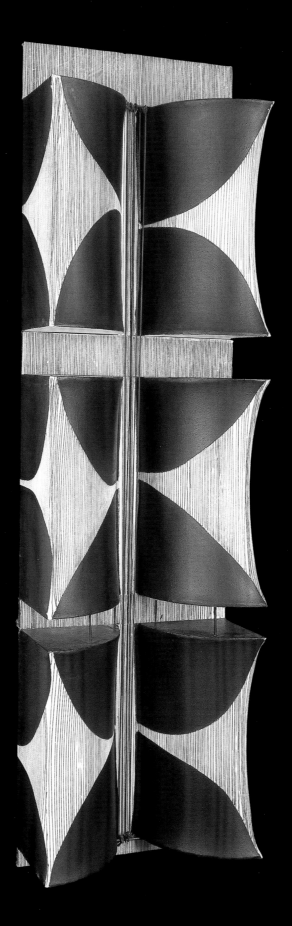

27 **Construction**,1966. Painted canvas over wood, 167.6 × 49.2 × 24 cm. Collection of the Artist

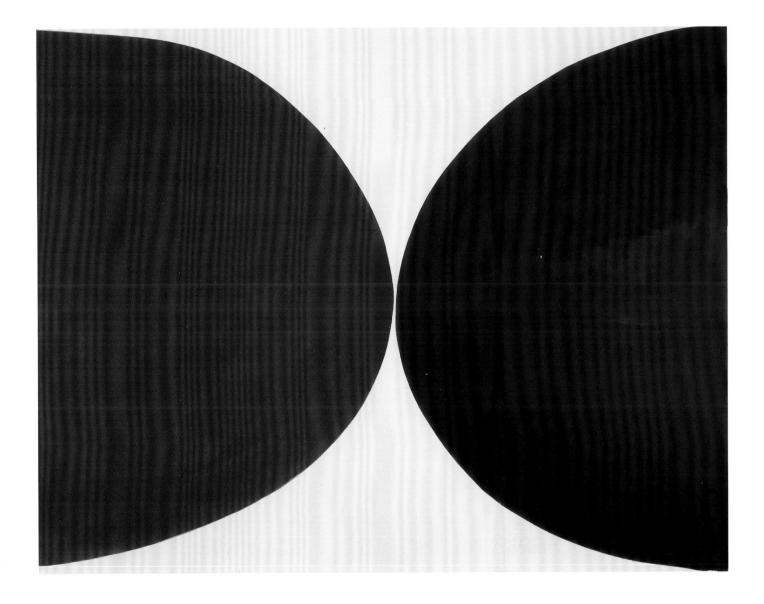

28 **Red, Black and White**, 1967. Acrylic on canvas, 198 × 259 cm. Innocent Fine Art Ltd, Bristol

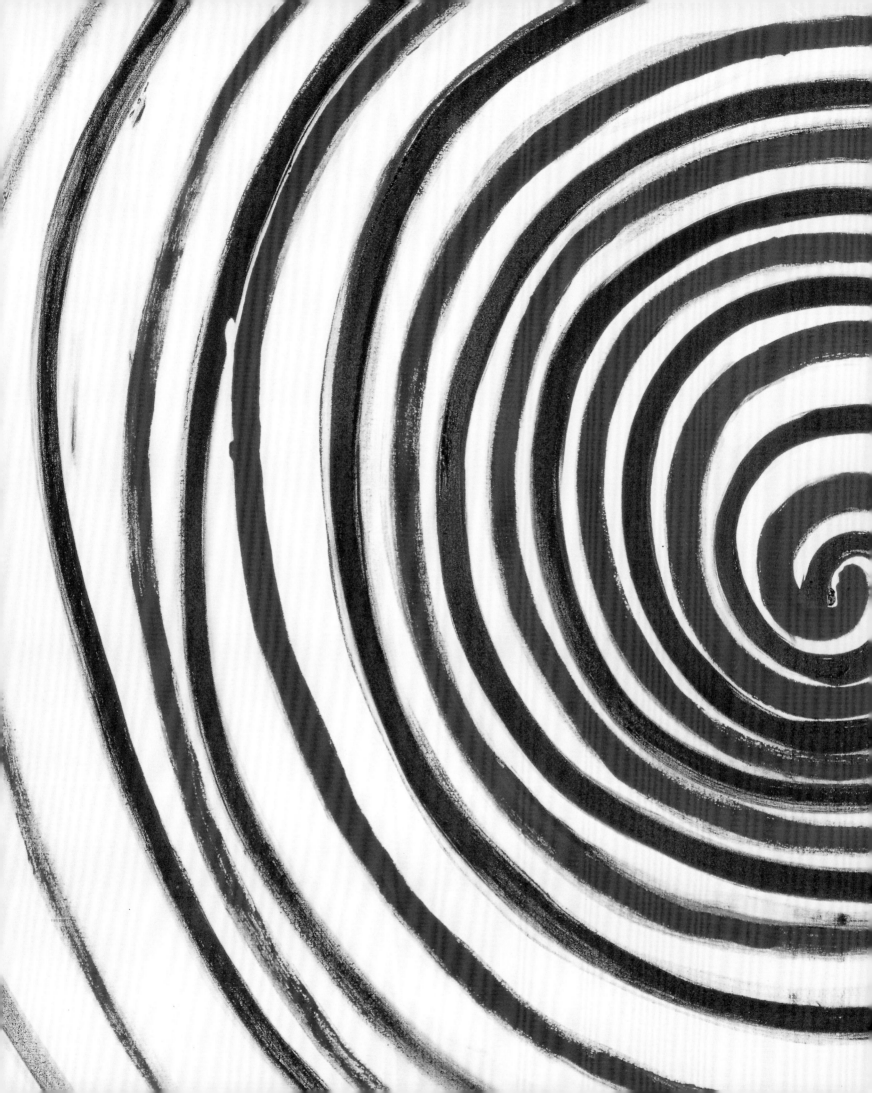

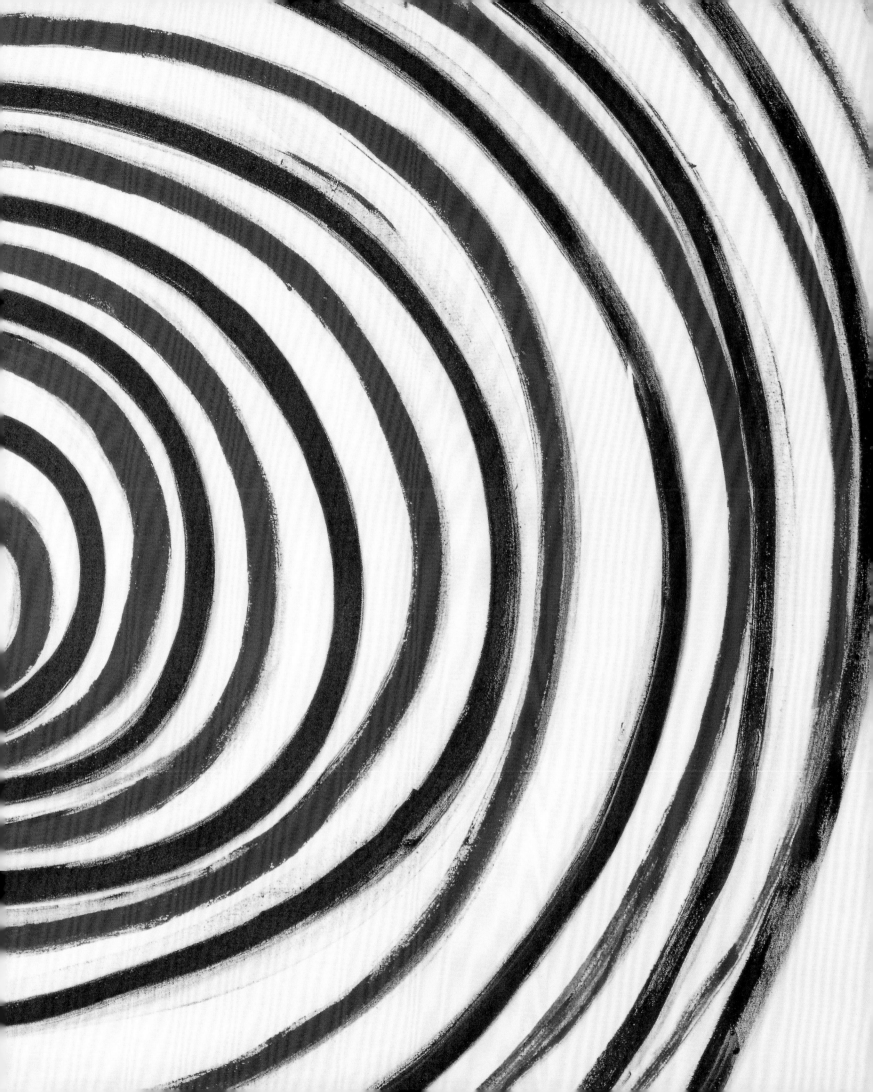

Memory and Imagination: 1970–2000

Stacked Red Pisa, 1971, cat. 29

This is part of a whole series of suspended forms. Some were three-dimensional: my studio in Banbury was full of painted tubes of canvas filled with polystyrene granules. I have always liked that kind of looped shape. It is in every landscape, every half moon, and because it is such a universal shape I can do anything I like with it. I had been to Pisa with the Art History Department of Reading University. The painting reminds me of the feeling I got looking at the lean of the tower.

Through Blacks, 1972–73, cat. 30

While making *Through Blacks* I got the experience of seeing the blue side of black, the red side of black and the yellow side of black. When doing paintings like this I mix the colours for about fifteen weeks, adding little bits of red, yellow and blue until I break to the yellow side of black, the blue side and so on: it's a very long job. Then I cut all the shapes because I've got a rhythm in the semicircle. The colours on the left-hand side are the ones that I was mixing from. When you are mixing from yellow, red and blue, you are going to get a hell of a range. It's a side of me that's opposite to the mad expressionist side.

Through Blues, 1975, cat. 31

I'm now free from copying anything: the shape is not related to a woman's bottom, it's not related to boats, it's my personal shape and it's free. I can do anything I want, I can make it faster or slower, the canvas thicker or thinner, and I can paint it any colour I want in the range that I am doing and then I get the magic of all the shapes in between. For me, it's an exercise which I loved taking on. The passion comes through the many degrees of colour and the dancing rhythm. Much to my surprise, the little dancing figures are like those Matisse used at one time.

Black Sun, 1978, cat. 32

> *Black wherein all colours are composed*
> *And unto which they all at last return;*
> *Thou colour of the sun where it doth burn*
> *And shadow where it cools.*

Lord Herbert of Cherbury (1582–1648), 'Sonnet to Black'

Black is the container of all colour. As I've spent so much time making blacks and teaching students to make blacks from red, yellow and blue it's a very important part of my painting life. While teaching I would try to make people see the colour in black. In Matisse or Bonnard you see purple shadows under a blue plate, fantastic.

Shortly after painting this I returned to Cyprus. Early in the morning there you can get a sun and blue moon, and you can stand between the two. Of course when you lie down and look at the sun

you get a lot of black spots in your eyes, and that's what's happening here. Anyway, I like a big black circle on yellow, it seems to work. It's a comfortable feeling I try to give, not an uncomfortable one.

Newlyn Rhythms, 1981–88, cat. 33

This is similar to the *Through* paintings but the trial here is a square within a square. Originally all these lines were marked according to the Golden Section, to determine where the curve turns, which means that every shape has a proportional relationship to each other. As soon as you put some colour in a shape it appears either bigger or smaller, or faster or slower. But when I really come to do all the work I have to forget about all the Golden Sections that I have marked out and shove them along a bit. I always remember Victor Pasmore used to do that too, so I don't feel so bad about it. I am using discord and harmony and slowness and fastness.

Blue for Newlyn, 1989, cat. 34

There's a black moon in here, twilight colours and stacked colours down the side. It's a nice big canvas and I enjoyed doing it. That's what counts. Too much agony doesn't come off sometimes. The sharpness against the softness is quite important and that's pretty soft but it has such positive shapes and the distance of the colour is quite strong.

Black Olives for Lorca, 1989, cat. 35

> *Córdoba.*
> *Far away and alone.*
> *Black pony, big moon,*
> *and olives in my saddle-bag.*
>
> *Although I know the roads*
> *I'll never reach Córdoba.*
> *Through the plain, through the wind,*
> *Black pony, red moon.*
>
> *Death is looking at me*
> *from the towers of Córdoba.*
> *Ah! How long the road!*
> *Ah! my valiant pony!*
>
> *Ah! that death should wait me*
> *before I reach Córdoba!*
> *Córdoba.*
> *Far away and alone.*
>
> Federico García Lorca (1898–1936), 'Song of the Rider'

I've got the black olives, and there is a moon in there too. Lorca is so simple, and so direct, and so full of colour and ideas. I was so much in love with the poetry at that time.

Spirals, 1991, cat. 36

I like spirals because they're forever. If you walk along the coast, as I used to do a lot, you pick up shells and you see those shapes. They are always a growth form. The aboriginals use spirals in their art and animals have spirals in their movements: when the wind blows on the tails of sheep, for instance, they go into spirals. The whole thing is part of life.

Sunblast, 1998, cat. 37

This painting is based on the sunrise but has an explosive liberty which is not to do with any sunrises at all. If you make coloured marks like that you get the best white in the world in the centre. I got that from Russian Constructivism.

October 12, Lizard Sunrise, 1999, cat. 38

Over the years I must have taken hundreds of photographs of sunrises, which are never the same and change every two seconds. It was a question of feeling right about the colour. Is it yellow, is it orange, what's the colour round it? The canvas had been [in my studio] for a long time and one Sunday morning, having had a good look at the sunrise, I thought 'I've got to take the gamble'. I got that colour in the centre, which was important and which I had never got before. I knew I had made it. It was nerve-racking to finish it off and not to lose what I had got.

Exclamation Mark, 2000, cat. 39

I am several persons: I am a person who would like to be a minimal artist and I'm also a person who likes people and painting people. Black and white and red I think are superb. You think of Malevich with his black cubes or Lissitzky who can write 'CCCP' and make it into a painting with one exclamation mark, which took me out of this world when I saw it. Those are my great influences. They had the power to paint with such simplicity because they believed in the Revolution, and they had the power to do it at that time. If you believe, it will work.

29 **Stacked Red Pisa**, 1971. Acrylic on canvas, 243.84 × 182.88 cm. Collection of the Artist

30 **Through Blacks**, 1972–73. Oil, acrylic and collage on canvas, 213.4 × 80 cm. Private collection

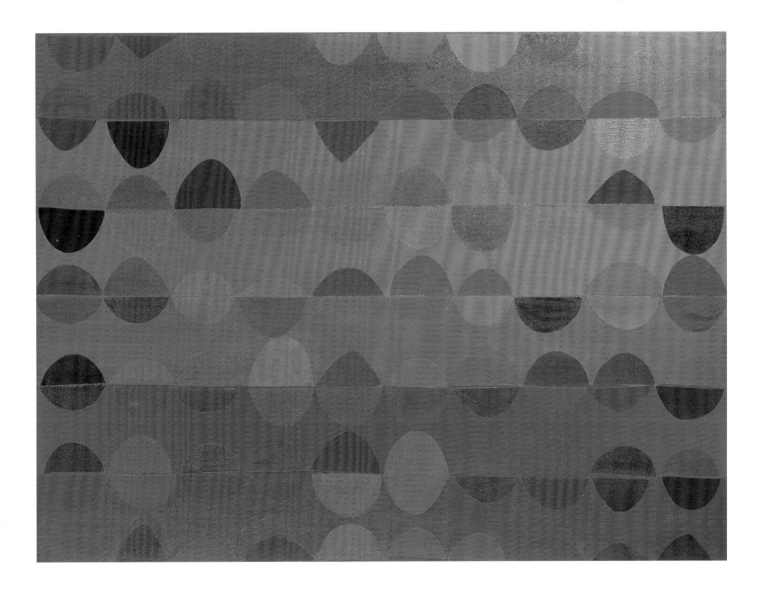

31 **Through Blues**, 1975. Oil and collage on canvas, 197 × 260 cm. Frances and John Sorrell

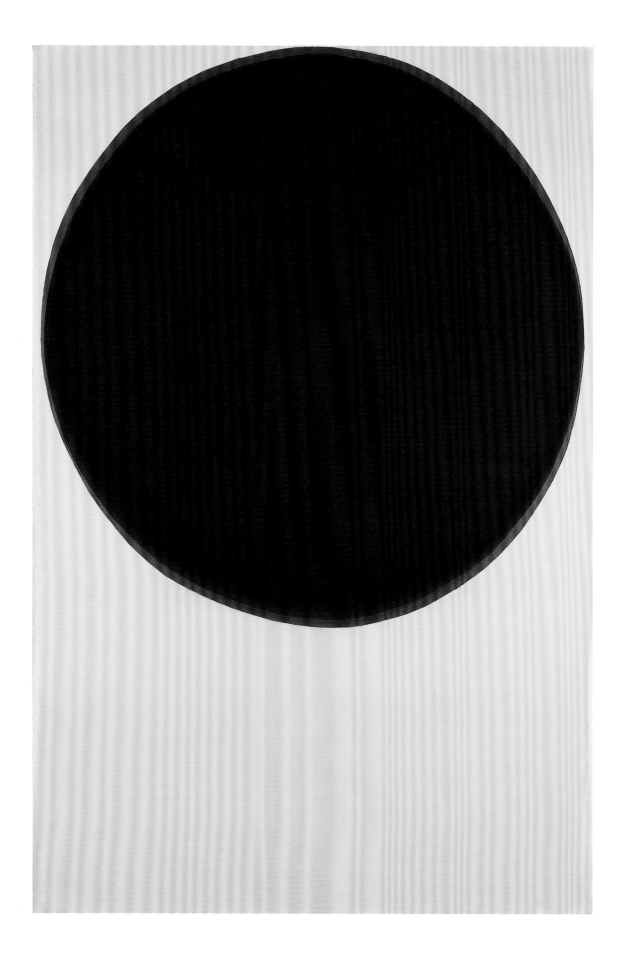

32 **Black Sun**, 1978. Acrylic on canvas, 236 × 158 cm. Collection of the Artist

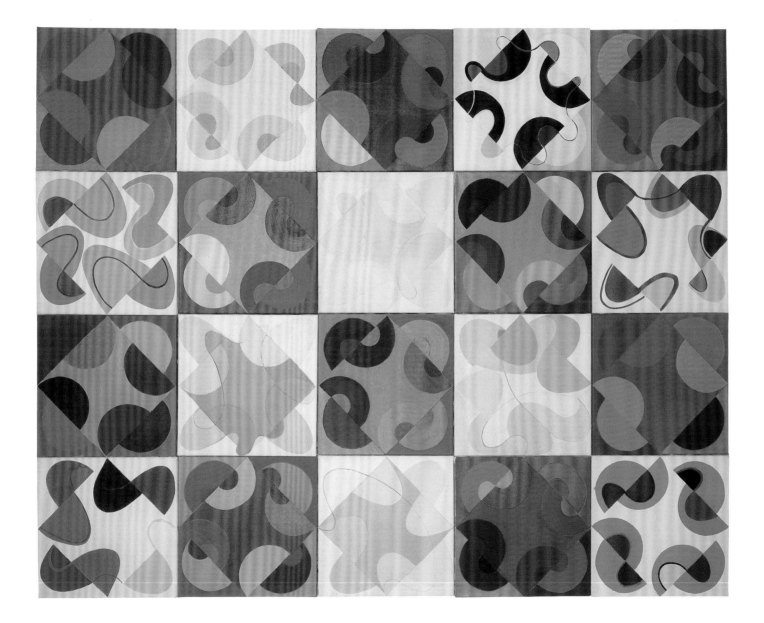

33 Newlyn Rhythms, 1981–88. Acrylic and collage on 20 canvases, 223.5 × 279.5 cm. Private collection

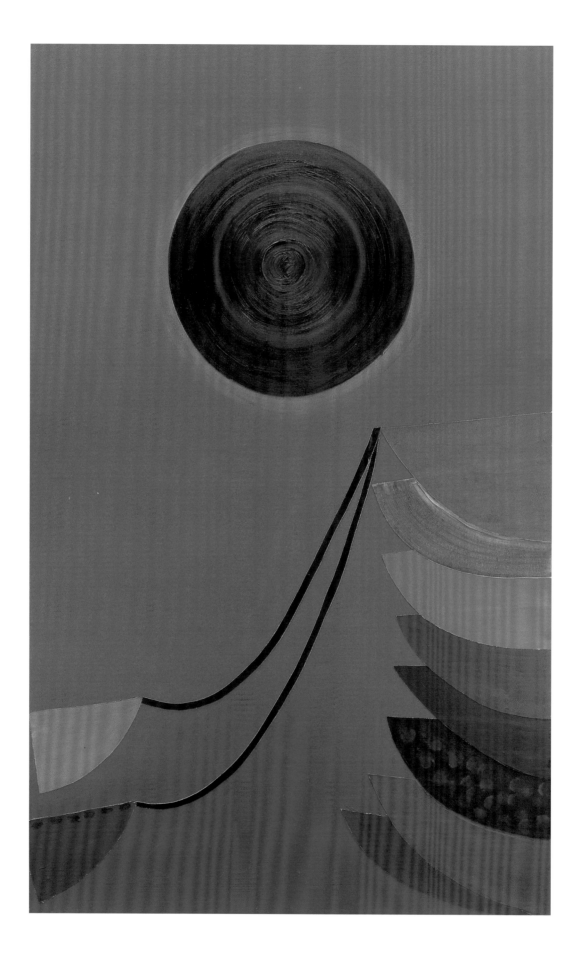

34 **Blue for Newlyn**, 1989. Oil and acrylic, 226.06 × 139.7 cm. Private collection

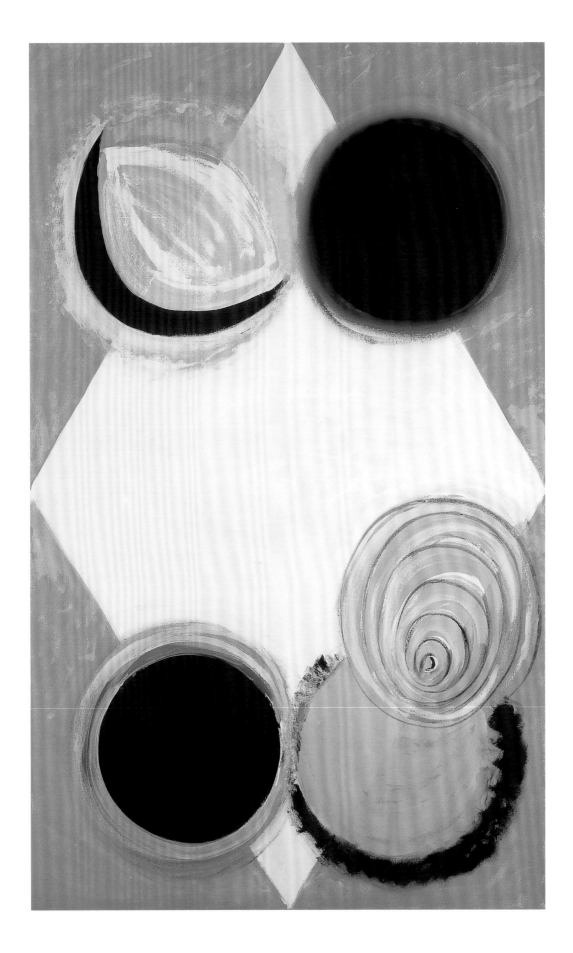

35 **Black Olives for Lorca**, 1989. Acrylic on canvas, 226 × 139.5 × 10 cm. John and Marilyn Wilkie

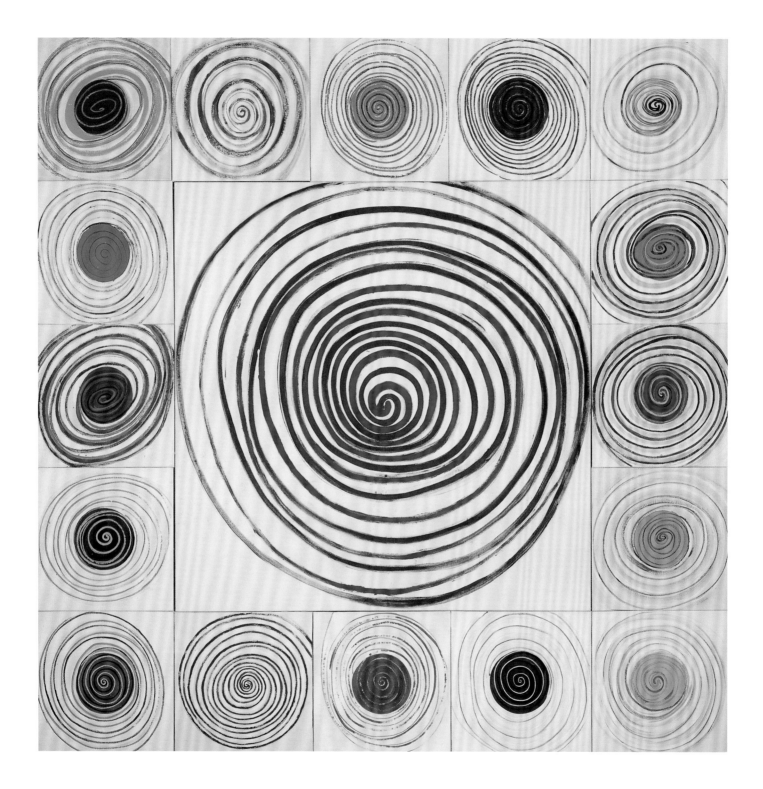

36 Spirals, 1991. Acrylic on canvas, 317 × 317 cm. McGeary Gallery, Brussels

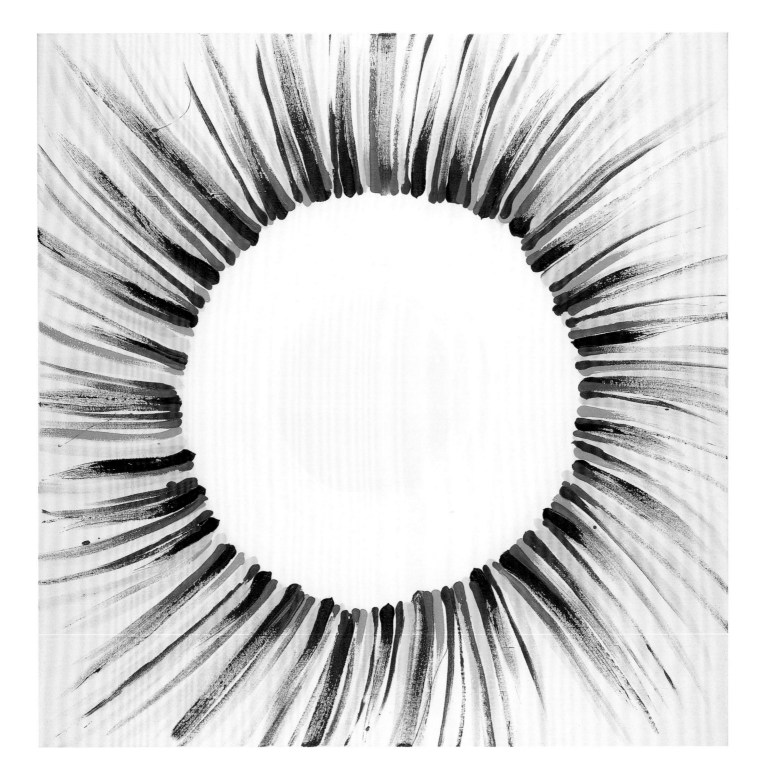

37 **Sunblast**, 1998. Acrylic on canvas, 152.4 × 152.4 cm. Mr and Mrs W. F. Couch

38 October 12, Lizard Sunrise, 1999. Acrylic on canvas, 182.88 × 182.88 cm. Collection of the Artist

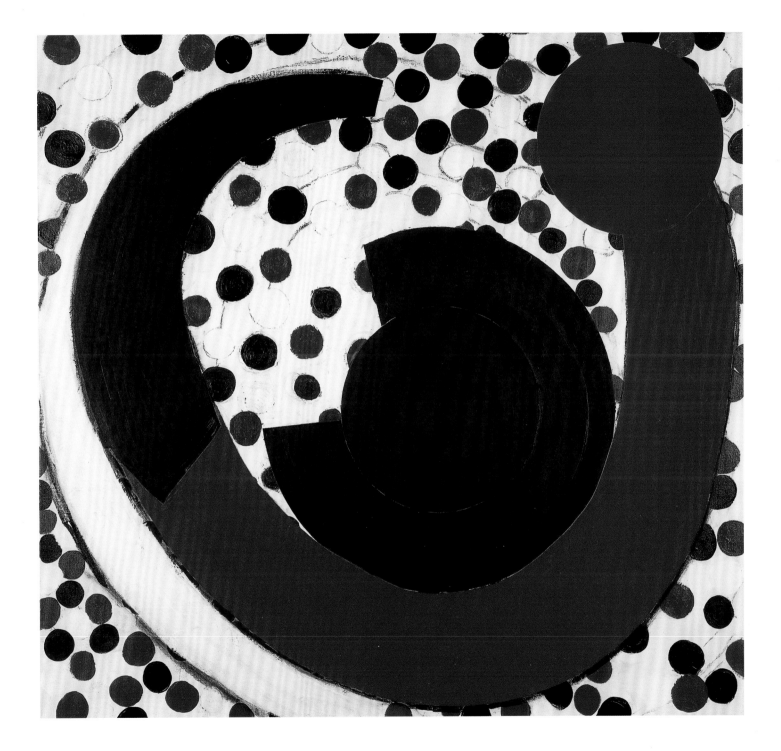

39 **Exclamation Mark**, 2000. Acrylic and collage on canvas, 134.62 × 142.24 cm. Collection of the Artist

List of Works

1
Door in Wall, Beaufort Street
1946–47
Oil on board
26 × 17.5 cm
Private collection

2
The Chair
1947
Oil on canvas
61 × 50.8 cm
Collection of the Artist

3
Mrs Pollard, Eddy and Cocking, Back Road West, St Ives
c. 1947
Oil on board
43.2 × 74.3 cm
Private collection, Courtesy Belgrave Gallery

4
Battersea Park
1947
Oil on board laid on panel
30.48 × 45.72 cm
Private collection, Courtesy Belgrave Gallery

5
Miss Humphries
1948
Oil on canvas
76.2 × 63.5 cm
Collection of the Artist

6
Self-portrait
1948–49
Oil on canvas laid on board
45 × 25.4 cm
Private collection, Courtesy Belgrave Gallery

7
Madrigal
1949
Oil on canvas
71 × 91.4 cm
Leamington Spa Art Gallery and Museum, The Royal Pump Rooms (Warwick District Council)

8
Walk Along the Quay
1950
Oil on canvas
152.5 × 56 cm
Private collection

9
Black and White Movement on Blue and Green II
1951–52
Oil on canvas
111.8 × 86.3 cm
Scottish National Gallery of Modern Art, Edinburgh

10
Yellow Painting
1952
Oil and collage on board
176.5 × 122 cm
Private collection

11
Leeds Painting II
1954–56
Oil on hessian
167.6 × 182.9 cm
Private collection

12
Yellow Triptych
1957–59
Oil on board
228.5 × 365.8 cm
Tate, London 2000

13
Red, Black and White, Leeds
1955
Oil on board
122 × 182.8 cm
T. L. Johnson

14
Blue Winter
1956
Oil on board
121 × 190.5 cm
The British Council

15
Black Wedge
1959
Oil on canvas
104.14 × 154.94 cm
Private collection

16
Winter Nude
1959
Oil on canvas
50.8 × 61 cm
Private collection

17
Three Graces
1960
Oil, collage and charcoal on canvas
198 × 243.8 cm
Bristol Museums & Art Gallery

18
Force 8
1960
Oil on canvas
221 × 173.4 cm
Ferens Art Gallery: Kingston-upon-Hull City Museums and Art Galleries

19
Three Forms
1960
Oil on canvas
122 × 122 cm
Private collection

20
Blue Linen Figure
1960
Oil on canvas
61 × 41 cm
Private collection

21
Laced Grace (prototype)
1962
Oil and collage on canvas
61 × 50.8 cm
Private collection, Courtesy Belgrave Gallery

22
M17, October 1962
1962
Oil on canvas
182.9 × 182.9 cm
The British Council

23
SS99
1962–63
Oil and collage on canvas
152.3 × 102 × 2.2 cm
Private collection

24
September 1964
1964
Oil on canvas
152.5 × 91.5 cm
Private collection

25
Spring
1966
Acrylic on canvas
220.98 × 172.72 cm
Collection of the Artist

26
Mae West
c. 1965
Oil paint and wood on canvas
121 × 98 × 46 cm
Collection of the Artist

27
Construction
1966
Painted canvas over wood
167.6 × 49.2 × 24 cm
Collection of the Artist

28
Red, Black and White
1967
Acrylic on canvas
198 × 259 cm
Innocent Fine Art Ltd, Bristol

29
Stacked Red Pisa
1971
Acrylic on canvas
243.84 × 182.88 cm
Collection of the Artist

30
Through Blacks
1972–73
Oil, acrylic and collage on canvas
213.4 × 80 cm
Private collection

31
Through Blues
1975
Oil and collage on canvas
197 × 260 cm
Frances and John Sorrell

32
Black Sun
1978
Acrylic on canvas
236 × 158 cm
Collection of the Artist

33
Newlyn Rhythms
1981–88
Acrylic and collage on 20 canvases
223.5 × 279.5 cm
Private collection

34
Blue for Newlyn
1989
Oil and acrylic
226.06 × 139.7 cm
Private collection

35
Black Olives for Lorca
1989
Acrylic on canvas
226 × 139.5 × 10 cm
John and Marilyn Wilkie

36
Spirals
1991
Acrylic on canvas
16 small canvases, one large central canvas
Overall dimensions 317 × 317 cm
McGeary Gallery, Brussels

37
Sunblast
1998
Acrylic on canvas
152.4 × 152.4 cm
Mr and Mrs W. F. Couch

38
October 12, Lizard Sunrise
1999
Acrylic on canvas
182.88 × 182.88 cm
Collection of the Artist

39
Exclamation Mark
2000
Acrylic and collage on canvas
134.62 × 142.24 cm
Collection of the Artist

Select Bibliography

Compiled by Chris Stephens

Lawrence Alloway, ed., *Nine Abstract Artists*, London, 1954 [with statements by Terry Frost, Adrian Heath, Anthony Hill, Kenneth Martin and others]

David Brown, ed., *St Ives: Twenty Five Years of Painting, Sculpture and Pottery*, Tate Gallery, London, 1985

Peter Davies, 'Notes on the St Ives School', *Art Monthly*, no. 48, July–August 1981

Terry Frost, 'What I Think Today', *Penwith Society Broadsheet*, no. 4, 1953

Terry Frost, Lincolnshire Arts Association, Lincoln, 1967

Terry Frost: Paintings, Drawings and Collages, Arts Council/South West Arts, 1976–7 [with introduction by David Brown]

Terry Frost: Painting in the 1980s, University of Reading, 1986 [with essay by Adrian Heath]

Terry Frost: Paintings 1948–89, Mayor Gallery, London, 1990 [with introduction by Ronnie Duncan]

Terry Frost with Mike von Joel, 'Still Crazy After All These Years', *Artline*, vol. 4, no. 8, 1989, pp. 16–24

Margaret Garlake, *New Art New World: British Art in Postwar Society*, New Haven and London, 1998

Patrick Heron, 'London: Alan Davie and Terry Frost', *Arts (NY)*, April 1956, pp. 12–13; repr. in *Painter as Critic: Patrick Heron: Selected Writings*, ed. Mel Gooding, London, 1998

Patrick Heron, 'London', *Arts (NY)*, October 1957, pp. 16–17

Patrick Heron, 'London', *Arts (NY)*, October 1958, pp. 20–1

J. P. Hodin, 'Terry Frost', *Quadrum*, May 1956

Elizabeth Knowles, ed., *Terry Frost*, Aldershot, 1994 [with a personal narrative by David Lewis and contributions by David Archer, Ronnie Duncan, Adrian Heath and Linda Saunders]

Adrian Lewis, 'The Fifties: British Avant-garde Painting', *Artscribe*, nos 34–6, March, June and August, 1982

Chris Stephens, *Terry Frost*, London, 2000

Photographic Credits

Amsterdam, Stedelijk Museum/Barnett Newman © DACS, NY and DACS, London 2000, fig. 9

Bob Berry, cat. 10

Bristol © Bristol Museums and Art Gallery, cat. 17

Cambridge, Kettle's Yard, University of Cambridge, fig. 7

Alexander Rodchenko © DACS 2000, fig. 6

Edinburgh, The Scottish National Gallery of Modern Art, photo by Antonia Reeve, cat. 9

Roy Fox, cats 1, 3, 6, 13, 15, 16, 19, 31, 33

Terry Frost © courtesy the artist, fig. 8

Grahame Jackson, cat. 23

London, Bridgeman Art Library/Haags Gemeentemuseum, Netherlands/El Lissitzky © DACS 2000, fig. 5

London © National Gallery, fig. 1

London © Tate, London 2000, cat. 12, fig. 2

Colin Mills, cat. 11

New York, The Museum of Modern Art photograph © 2000/František Kupka ADAGP, Paris and DACS, London 2000, fig. 4

Paris, Centre Georges Pompidou Musée National d'Art Moderne/František Kupka © ADAGP, Paris and DACS, London 2000, fig. 3

Richmond & Rigg Photography, Hull, cat. 18

Sheffield, courtesy Sheffield Galleries & Museums Trust, cat. 8

Steve Tanner, cats 2, 5, 20, 24, 25, 26, 27, 29, 32, 35, 37, 38, 39

Rodney Todd-White & Son, cat. 22

© Alex Tymkóv, cat. 34

Royston Walters, cat. 30

Alan Watson, cat. 7

All illustrated works by Terry Frost © the artist

Marsh Christian Trust
R C Martin
Mrs Jack Maxwell
Mrs Annabella McAlpin
Mrs M C W McCann
The Mercers' Company
Lt Col L S Michael OBE
Mr and Mrs Peter Morgan
Mr and Mrs I Morrison
Mr Harry Moss
Jim Moyes
Marlene Burston
Mr and Mrs Carl Anton Muller
Paul and Alison Myners
John Nickson and Simon Rew
Sir Peter Osborne
Mr Michael Palin
Mr and Mrs Vincenzo Palladino
Mr and Mrs Gerald Parkes
Mrs Chrysanthy Pateras
John Pattisson
Lynda Pearson
Miss Karen Phillipps
Mr Godfrey Pilkington
George and Carolyn Pincus
Mr and Mrs William A Plapinger
Miss Victoria Provis
Barbara Rae RA
John and Anne Raisman
Sir David and Lady Ramsbotham
Mrs Jean Redman-Brown
Mr T H Reitman
Sir John and Lady Riddell
Mr and Mrs Ian Rosenberg
Alastair and Sarah Ross Goobey
Mr and Mrs Kerry Rubie
Mr Frank Russell
Mr John J Ryan III
Mr and Mrs Victor Sandelson
Mr Adrian Sassoon
Dr Lewis Sevitt
Mr Christopher and Lady Mary Gaye Shaw
The Countess of Shaftesbury
Mr and Mrs D M Shalit
Mr and Mrs Clive Sherling
Mrs Lois Sieff OBE
Mrs Roama Spears
Mr and Mrs Nicholas Stanley
Mrs Jack Steinberg
Mr and Mrs David Stileman
Sir Christopher Hogg and Dr Miriam Stoppard
Mr and Mrs R W Strang
David and Linda Supino
Mr and Mrs David Swift
Mr and Mrs John D Taylor
Mr and Mrs Julian Treger
Mr and Mrs Max Ulfane
Corona Extra Beer
Mrs Catherine Vlasto
Mrs Claire Vyner
John B Watton
Mr and Mrs Jeffrey M Weingarten
Edna and Willard Weiss
Mrs Gerald Westbury
Mr and Mrs Ami Wine
and others who wish to remain anonymous

Schools Patrons Group

AHRB
The Charlotte Bonham-Carter Charitable Trust
Mrs Stephen Boyd
The Clothworkers' Foundation
The Ernest Cook Trust
Mr Simon Copsey
Crabtree & Evelyn
Mr and Mrs Keith Dawson
The D'Oyly Carte Charitable Trust
The Gilbert & Eileen Edgar Foundation
The Eranda Foundation
P H Holt Charitable Trust
Dr and Mrs Robert Lefever
The Leverhulme Trust
The Hon Charles Low
Stuart and Ellen Lyons Charitable Trust
The Mercers' Company
The Henry Moore Foundation
Robin Heller Moss
The Worshipful Company of Painter-Stainers
Pickett Fine Leather Ltd
Edith and Ferdinand Porjes Charitable Trust
The Radcliffe Trust
Rio Tinto plc
Mr Charles Saatchi

Pauline Denyer Smith and Paul Smith CBE
The South Square Trust
Mr and Mrs Michele Sportelli
Mr and Mrs Denis Tinsley
The Celia Walker Art Foundation
The Harold Hyam Wingate Foundation
and others who wish to remain anonymous

General Donors

Mr Charles Akle
Mr Keith Bromley
Miss Jayne Edwardes
Lady Sainsbury
The Schneer Foundation Inc
and others who wish to remain anonymous

American Associates of The Royal Academy Trust

Benefactors
American Express
Mrs Russell B Aitken
Mr and Mrs Sid R Bass
Mr Walter Fitch III
Mrs Henry Ford II
The Horace W Goldsmith Foundation
The Hearst Corporation
Mrs Henry J Heinz II
Mr and Mrs Donald Kahn
Mr and Mrs John L Marion
Mrs Nancy B Negley
Ms Diane A Nixon
Mrs Arthur M Sackler
Mrs Louisa S Sarofim
The Starr Foundation
US Trust Company of New York
Mr and Mrs Frederick B Whittemore
and others who wish to remain anonymous

Sponsors
Mrs Jan Cowles
Lady Mary Fairfax
Mrs Donald R Findlay
Mr D Francis Finlay
Mr and Mrs Lewis P Grinnan Jr
Mr James Kemper Jr
Mrs Linda Noe Laine
Mrs Janice H Levin
Mrs Deborah Loeb Brice
Mr Edmond J Safra
Mr and Mrs Vernon Taylor Jr
Mr Lee Weissman
and others who wish to remain anonymous

Patrons
Ms Helen Harting Abell
Mr and Mrs Stephen D Bechtel Jr
Mrs William J Benedict
Mr Donald A Best
Mr and Mrs Henry W Breyer III
Mrs Mildred C Brinn
Dr and Mrs Robert Carroll
Mr William L Clark
Anne S Davidson
Ms Zita Davisson
Mr and Mrs Charles Diker
Mrs Charles H Dyson
Mrs John W Embry
Mrs A Barlow Ferguson
Mr Ralph A Fields
Mr and Mrs Lawrence S Friedland
Mrs Betty N Gordon
Mrs Gloria Gurney
Mrs Melville Wakeman Hall
Mrs Richard L Harris
Mr O D Harrison Jr
Mr and Mrs Gurnee F Hart
Mr and Mrs Gustave M Hauser
The Honorable Marife Hernandez
Mr Robert J Irwin
Ms Betty Wold Johnson and Mr Douglas Bushnell
The Honorable and Mrs Eugene Johnston
Mr William W Karatz
Mr and Mrs Stephen M Kellen
Mr Gary A Kraut
Mrs Katherine K Lawrence
Mr William D Lese and Ms Serena Harding-Jones
Mr and Mrs William M Lese
Mrs John P McGrath
Ms Elizabeth McHugh-Kahn
Mrs Mark Millard
Mrs Anne Miller
Mrs Barbara T Missett
Mr Paul D Myers
Mr and Mrs Wilson Nolen

Mr and Mrs Jeffrey Pettit
Mr Robert S Pirie
Dr and Mrs Meyer P Potamkin
Mrs Rochelle W Prather
Mr and Mrs Derald H Ruttenberg
Mrs Frances G Scaife
Ms Jan Blaustein Scholes
Mrs Frederick M Stafford
Mr and Mrs Stephen Stamas
Mr and Mrs Robert L Sterling Jr
Mrs Kenneth Straus
Mr Arthur O Sulzberger and Ms Alison S Cowles
Mrs Royce Dean Tate
Mr and Mrs A Alfred Taubman
Ms Britt Tidelius
Mrs Vincent S Villard Jr
Mrs Martha Griffin White
Mrs Sara E White
Dr and Mrs Robert D Wickham
Mr Robert W Wilson
Mr and Mrs Kenneth Woodcock
and others who wish to remain anonymous

Friends of The Royal Academy

Patron Friends
Mr Z Aram
Mr Paul Baines
Mrs J V Barker
Mrs Yvonne Barlow
Mr P F J Bennett
Mr and Mrs Sidney Corob
Mr Michael Godbee
Dr and Mrs Alan J Horan
Mr David Ker
Dr Abraham Marcus
Mrs Maureen D Metcalfe
Mr R J Mullis
Mr and Mrs David Peacock
Mr Keith M Reilly
The Hon Sir Steven Runciman CH
Mr and Mrs Derald H Ruttenberg
Mr Nigel J Stapleton
Mr Robin Symes
Mrs K L Troughton
Mr and Mrs Timothy Vignoles
Mrs Cynthia H Walton
Mrs Roger Waters
The Hon Mrs Simon Weinstock
Miss Elizabeth White
Mr David Wolfers
Mrs I Wolstenholme
and others who wish to remain anonymous

Supporting Friends
Mr and Mrs D L Adamson
Mr Richard B Allan
Mrs M Allen
Mr Peter Allinson
Mr Ian Anstruther
Mr Brian A Bailey
Mr B P Bearne
Mrs Susan Besser
Mrs C W T Blackwell
Mrs J M Bracegirdle
Mr Cornelius Broere
Mrs Anne Cadbury OBE JP DL
Mr W L Carey-Evans
Miss E M Cassin
Mr R A Cernis
Mrs Norma Chaplin
Mr S Chapman
Mr and Mrs John Cleese
Mrs Ruth Cohen
Mrs D H Costopoulos
Mr and Mrs Chris Cotton
Mrs Nadine Crichton
Mrs Saeda H Dalloul
Mr Julian R Darley
Mr John Denham
Miss N J Dhanani
The Marquess of Douro
Mr Kenneth Edwards
Mrs Nicholas Embiricos
Mrs B D Fenton
Mrs R H Goddard
Mrs D Goodsell
Mr Gavin Graham
Lady Grant
Mrs Richard Grogan
Miss Susan Harris
Malcolm P Herring Esq
Mr R J Hoare
Mr Charles Howard
Mrs O Hudson

Mrs Manya Igel
Mr S Isern-Feliu
Mrs Jane Jason
Mrs G R Jeffries
Mr Roger A Jennings
Mr Harold Joels
Mr and Mrs S D Kahan
Mrs P Keely
Mr and Mrs J Kessler
Mr D H Killick
Mr N R Killick
Mrs Carol Kroch
Mrs Joan Lavender
Mr and Mrs David Leathers
Mr Owen Luder CBE PRIBA FRSA
Miss Julia MacRae
Mrs Susan Maddocks
Mr Donald A Main
Ms Rebecca Marek
Lord Marks of Broughton
Mr J B H Martin
Mrs Gillian M S McIntosh
Mr J Moores
Mr A Morgan
R Naylor and C Boddington
Mrs Elizabeth M Newell
Miss Kim Nicholson
Mrs E M Oppenheim Sandelson
Mr Robert Linn Ottley
Mr Brian Oury
Mrs J Pappworth
Mrs M C S Philip
Mrs Anne Phillips
Mr Ralph Picken
Mr D B E Pike
Mr Benjamin Pritchett-Brown
Mr F Peter Robinson
Mr D S Rocklin
Mrs A Rodman
Mr and Mrs O Roux
Dr Susan Saga
Lady Sainsbury
The Rt Hon Sir Timothy Sainsbury
Mrs Susanne Salmanowitz
Mr Anthony Salz
Dr I B Schulenburg
Mrs D Scott
Mr and Mrs Richard Seymour
Mr Mark Shelmerdine
Mr R J Simmons CBE
Mr P W Simon
Mr John H M Sims
Miss L M Slattery
Dr and Mrs M L Slotover
Mrs P Spanoghe
Professor Philip Stott
Mr James Stuart
Mr J A Tackaberry
Mrs J A Tapley
Mrs Andrew Trollope
Mr W N Trotter
Mrs Catherine I Vlasto
Mr and Mrs Ludovic de Walden
Miss J Waterous
Mrs Claire Weldon
Mr Frank S Wenstrom
Mrs Sheree D Whatley
Mr David Wilson
Mr W M Wood
Mr R M Woodhouse
Dr Alain Youell
and others who wish to remain anonymous

Corporate Membership of The Royal Academy of Arts

Launched in 1988, the Royal Academy's Corporate Membership Scheme has proved highly successful. With 105 members it is now the largest membership scheme in Europe. Corporate membership offers company benefits to staff and clients and access to the Academy's facilities and resources. Each member pays an annual subscription to be a Member (£7,000) or Patron (£20,000). Participating companies recognise the importance of promoting the visual arts. Their support is vital to the continuing success of the Academy.

Corporate Membership Scheme

Corporate Patrons
Arthur Andersen
Bloomberg LP
BNP Paribas
BP Amoco p.l.c.
Debenhams Retail plc
Deutsche Bank AG

The Economist Group
Ernst & Young
GE Group
Glaxo Wellcome plc
Merrill Lynch
Morgan Stanley International

Corporate Members
Apax Partners & Co. Ltd.
Athenaeum Hotel
Aukett Limited
Bacon and Woodrow
Bank of America
Barclays plc
Bartlett Merton Ltd
Bass PLC
Bear, Stearns International Ltd
BG plc
Bluestone Capital Partners (UK) Ltd
Booz Allen & Hamilton International (UK) Ltd
Bovis Lend Lease Limited
BT plc
British Airways plc
British Alcan Aluminium plc
Bunzl plc
Cazenove & Co
CB Hillier Parker
CJA (Management Recruitment Consultants) Limited
Christie's
Chubb Insurance Company of Europe
Clayton Dubilier & Rice Limited
Clifford Chance
Colefax and Fowler Group
Cookson Group plc
Credit Agricole Indosuez
Credit Suisse First Boston
The Daily Telegraph plc
Diageo plc
De Beers
E D & F Man Limited Charitable Trust
Eversheds
Foreign & Colonial Management plc
Gartmore Investment Management plc
Granada Group PLC
GKR & Associates Ltd
Heidrick & Struggles
HSBC plc
H J Heinz Company Limited
ICI
J Sainsbury plc
John Lewis Partnership
King Sturge
Kleinwort Benson Charitable Trust
Korn/Ferry International
KPMG
Kvaerner Construction Ltd
Lex Service PLC
Linklaters & Alliance
Macfarlanes
Marconi Ltd
Marsh Ltd
McKinsey & Co.
MoMart Ltd
Newton Investment Management Ltd
Old Mutual Asset Managers
Ove Arup Partnership
Pearson plc
The Peninsular and Oriental Steam Navigation Company
Pentland Group plc
PricewaterhouseCoopers
Provident Financial plc
Raytheon Systems Limited
Robert Fleming & Co. Ltd
Rowe & Maw
The Royal Bank of Scotland
Schroder Salomon Smith Barney
Schroders plc
Sea Containers Ltd.
SG
Slaughter and May
SmithKline Beecham
The Smith & Williamson Group
Sotheby's
Strutt & Parker
Sun Life and Provincial Holdings plc
Tiffany & Co.
TI Group plc
Tomkins PLC
Travelex
Trowers & Hamlins
Unilever UK Limited
United Airlines
UPC Services

Honorary Corporate Members
All Nippon Airways Co. Ltd
A.T. Kearney Limited
Cantor Fitzgerald
Goldman Sachs International Limited
London First
Reed Elsevier plc
Reuters Limited
Yakult UK Limited

Sponsors of Past Exhibitions
The President and Council of the Royal Academy thanks sponsors
of past exhibitions for their support. Sponsors of major exhibitions
during the last ten years have included the following:

Allied Trust Bank
 Africa: The Art of a Continent, 1995*
Anglo American Corporation of South Africa
 Africa: The Art of a Continent, 1995*
A.T. Kearney
 Summer Exhibition 99, 1999
 Summer Exhibition 2000, 2000
The Banque Indosuez Group
 Pissarro: The Impressionist and the City, 1993
BBC Radio One
 The Pop Art Show, 1991
BMW (GB) Limited
 Georges Rouault: The Early Years, 1903–1920. 1993
 David Hockney: A Drawing Retrospective, 1995*
British Airways Plc
 Africa: The Art of a Continent, 1995
BT
 Hokusai, 1991
Cantor Fitzgerald
 From Manet to Gauguin: Masterpieces from Swiss Private
 Collections, 1995
 1900: Art at the Crossroads, 2000
The Capital Group Companies
 Drawings from the J Paul Getty Museum, 1993
Chilstone Garden Ornaments
 The Palladian Revival: Lord Burlington and His House and Garden
 at Chiswick, 1995
Christie's
 Frederic Leighton 1830–1896, 1996
 Sensation: Young British Artists from The Saatchi Collection,
 1997
Classic FM
 Goya: Truth and Fantasy, The Small Paintings, 1994
 The Glory of Venice: Art in the Eighteenth Century, 1994
Country Life
 John Soane, Architect: Master of Space and Light, 1999
Corporation of London
 Living Bridges, 1996
The Dai-Ichi Kangyo Bank Limited
 222nd Summer Exhibition, 1990
The Daily Telegraph
 American Art in the 20th Century, 1993
 1900: Art at the Crossroads, 2000
De Beers
 Africa: The Art of a Continent, 1995
Debenhams Retail plc
 Premiums, 2000
 Schools Show, 2000
Deutsche Morgan Grenfell
 Africa: The Art of a Continent, 1995
Diageo plc
 230th Summer Exhibition, 1998
Digital Equipment Corporation
 Monet in the '90s: The Series Paintings, 1990
The Drue Heinz Trust
 The Palladian Revival: Lord Burlington and His House and Garden
 at Chiswick, 1995
 Denys Lasdun, 1997
 Tadao Ando: Master of Minimalism, 1998
The Dupont Company
 American Art in the 20th Century, 1993
Edwardian Hotels
 The Edwardians and After: Paintings and Sculpture from the
 Royal Academy's Collection, 1900–1950. 1990
Elf
 Alfred Sisley, 1992
Ernst & Young
 Monet in the 20th Century, 1999
Fondation Elf
 Alfred Sisley, 1992
Ford Motor Company Limited
 The Fauve Landscape: Matisse, Derain, Braque and Their Circle,
 1991
Friends of the Royal Academy
 Victorian Fairy Painting, 1997
The Jacqueline and Michael Gee Charitable Trust
 LIFE? or THEATRE? The Work of Charlotte Salomon, 1999

Générale des Eaux Group
 Living Bridges, 1996
Glaxo Wellcome plc
 Great Impressionist and other Master Paintings from the
 Emil G Buhrle Collection, Zurich, 1991
 The Unknown Modigliani, 1994
Goldman Sachs International
 Alberto Giacometti, 1901–1966. 1996
 Picasso: Painter and Sculptor in Clay, 1998
The Guardian
 The Unknown Modigliani, 1994
Guinness PLC (see Diageo plc)
 Twentieth-Century Modern Masters: The Jacques and Natasha
 Gelman Collection, 1990
 223rd Summer Exhibition, 1991
 224th Summer Exhibition, 1992
 225th Summer Exhibition, 1993
 226th Summer Exhibition, 1994
 227th Summer Exhibition, 1995
 228th Summer Exhibition, 1996
 229th Summer Exhibition, 1997
Guinness Peat Aviation
 Alexander Calder, 1992
Harpers & Queen
 Georges Rouault: The Early Years, 1903–1920. 1993
 Sandra Blow, 1994
 David Hockney: A Drawing Retrospective, 1995*
 Roger de Grey, 1996
The Headley Trust
 Denys Lasdun, 1997
The Henry Moore Foundation
 Alexander Calder, 1992
 Africa: The Art of a Continent, 1995
Ibstock Building Products Ltd
 John Soane, Architect: Master of Space and Light, 1999
The Independent
 The Pop Art Show, 1991
 Living Bridges, 1996
Industrial Bank of Japan, Limited
 Hokusai, 1991
Donald and Jeanne Kahn
 John Hoyland, 1999
Land Securities PLC
 Denys Lasdun, 1997
The Mail on Sunday
 Royal Academy Summer Season, 1992
 Royal Academy Summer Season, 1993
Marks & Spencer
 Royal Academy Schools Premiums, 1994
 Royal Academy Schools Final Year Show, 1994*
Martini & Rossi Ltd
 The Great Age of British Watercolours, 1750–1880. 1993
Paul Mellon KBE
 The Great Age of British Watercolours, 1750–1880. 1993
Mercury Communications
 The Pop Art Show, 1991
Merrill Lynch
 American Art in the 20th Century, 1993*
Midland Bank plc
 RA Outreach Programme, 1992–1996
 Lessons in Life, 1994
Minorco
 Africa: The Art of a Continent, 1995
Mitsubishi Estate Company UK Limited
 Sir Christopher Wren and the Making of St Paul's, 1991
Natwest Group
 Nicolas Poussin 1594–1665. 1995
The Nippon Foundation
 Hiroshige: Images of Mist, Rain, Moon and Snow, 1997
Olivetti
 Andrea Mantegna, 1992
Park Tower Realty Corporation
 Sir Christopher Wren and the Making of St Paul's, 1991
Peterborough United Football Club
 Art Treasures of England: The Regional Collections, 1997
Premiercare (National Westminster Insurance Services)
 Roger de Grey, 1996*
RA Exhibition Patrons Group
 Chagall: Love and the Stage, 1998
 Kandinsky, 1999
 Chardin 1699–1779, 2000
Redab (UK) Ltd
 Wisdom and Compassion: The Sacred Art of Tibet, 1992
Reed Elsevier plc
 Van Dyck 1599–1641, 1999
Reed International plc
 Sir Christopher Wren and the Making of St Paul's, 1991
Republic National Bank of New York
 Sickert: Paintings, 1992
The Royal Bank of Scotland
 Braque: The Late Works, 1997*
 Premiums, 1997

Premiums, 1998
Premiums, 1999
Royal Academy Schools Final Year Show, 1996
Royal Academy Schools Final Year Show, 1997
Royal Academy Schools Final Year Show, 1998
The Sara Lee Foundation
 Odilon Redon: Dreams and Visions, 1995
Sea Containers Ltd
 The Glory of Venice: Art in the Eighteenth Century, 1994
Silhouette Eyewear
 Egon Schiele and His Contemporaries: From the Leopold
 Collection, Vienna, 1990
 Wisdom and Compassion: The Sacred Art of Tibet, 1992
 Sandra Blow, 1994
 Africa: The Art of a Continent, 1995
Société Générale, UK
 Gustave Caillebotte: The Unknown Impressionist, 1996*
Société Générale de Belgique
 Impressionism to Symbolism: The Belgian Avant-Garde
 1880–1900. 1994
Spero Communications
 Royal Academy Schools Final Year Show, 1992
Texaco
 Selections from the Royal Academy's Private Collection, 1991
Thames Water Plc
 Thames Water Habitable Bridge Competition, 1996
The Times
 Wisdom and Compassion: The Sacred Art of Tibet, 1992
 Drawings from the J Paul Getty Museum, 1993
 Goya: Truth and Fantasy, The Small Paintings, 1994
 Africa: The Art of a Continent, 1995
Time Out
 Sensation: Young British Artists from The Saatchi Collection,
 1997
Tractabel
 Impressionism to Symbolism: The Belgian Avant-Garde
 1880–1900. 1994
Unilever
 Frans Hals, 1990
Union Minière
 Impressionism to Symbolism: The Belgian Avant-Garde
 1880–1900. 1994
Vistech International Ltd
 Wisdom and Compassion: The Sacred Art of Tibet, 1992
Yakult UK Ltd
 RA Outreach Programme, 1997–2000*
 alive: Life Drawings from the Royal Academy of Arts & Yakult
 Outreach Programme 2000

* Recipients of a Pairing Scheme Award, managed by Arts +
Business. Arts + Business is funded by the Arts Council of England
and the Department for Culture, Media and Sport.

Other Sponsors
Sponsors of events, publications and other items in the past
five years:

Asia House
Atlantic Group plc
Elizabeth Blackadder RA
BP Amoco p.l.c.
British Airways plc
Champagne Taittinger
Corona Beer
Foster and Partners
Green's Restaurant
HSBC Holdings plc
Hulton Getty Picture Collection
IBJ International plc
John Doyle Construction
Allen Jones RA
KLM UK
The Leading Hotels of the World
Met Bar
Michael Hopkins & Partners
Mikimoto
Morgan Stanley Dean Witter
Old Mutual
Polaroid (UK) Limited
Richard and Ruth Rogers
Rob van Helden
Royal & Sun Alliance Insurance Group plc
Strutt & Parker
ZFL